PAINTING NATURE

How to solve landscape problems

PAINTING NATURE

How to solve landscape problems

by Franklin Jones

 North Light Publishers

Published by North Light, an imprint of Writer's Digest Books,
9933 Alliance Road, Cincinnati, Ohio 45242.

Manufactured in Spain
First Printing 1978
Second Printing 1979
Third Printing 1985

Library of Congress Cataloging in Publication Data

Jones, Franklin, 1921-
 Painting nature

 1. Landscape painting—Technique. I. Title.
ND1342.J6 751.4 77-93216
ISBN 0-89134-119-6

Designed by Franklin Jones

Dedication

To my dearest wife, Florence, who does a lot more than feed me and care for my every need. She is my constant companion wherever my painting adventures take me, whether it be backpacking into the hills or trudging through knee-deep snow in subfreezing temperatures.

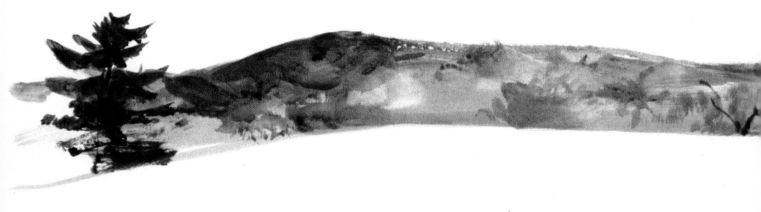

Contents

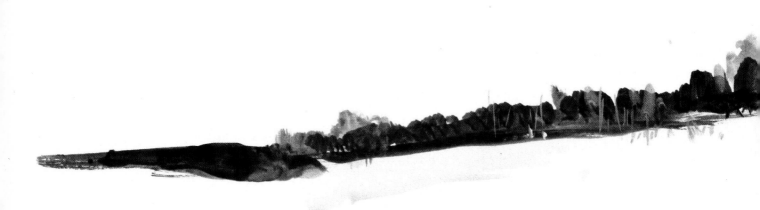

While some contend that the only way to learn the craft of painting is by painting, I find that one can save considerable time and frustration by observing the procedures and techniques of other artists. Of course the best way to do this would be to look over the shoulders of the artists and listen to their reasoning. Knowing why something is done is as important as seeing the application of paint.

Lacking a person-to-person contact, the next best approach is to have the artist record the various stages of his work and write a description of the procedures. In order to do this I photographed each phase of my work and made notes as I painted so you can "look over my shoulder."

The primary purpose of the book is to show a procedure for painting with each of the three mediums: oil, watercolor and acrylic, and to show some of the techniques used to capture the character of subjects frequently encountered in landscape painting.

By procedure, I refer to the order of putting down the paint on canvas or paper. In other words, which tones, the darks or the light, are put down first, second, etc., and which areas of an object are painted first. The purpose of a procedure is to allow the artist to achieve the end result with the greatest ease.

In the broadest terms the procedures for each medium are quite easy to state. With oil paints, one starts with the darkest areas of the scene and the largest masses of the objects. With watercolor, the traditional method is to start with the lightest washes and proceed to the darker passages, also developing the larger masses before putting in the smaller shapes.

Acrylic paints are used in both an opaque manner as one uses oil paints, or in a thin transparent manner as one uses watercolors. Or, both approaches may be used in the same painting. So the procedure would depend on the use. From dark to light when using the medium in a thick opaque approach or from light to dark when used as transparent washes.

This procedure may be varied for a particular result you wish to achieve. Hopefully my demonstrations will clarify these approaches and their variations. You'll see that it isn't a matter of dogmatic rules, but of using logic and anticipating the results you are after.

The techniques I will explore in this book, for capturing the character of different objects in nature, are offered only as a starting point for the beginning painter. Inevitably each artist will find his or her own way of expressing these forms, based on observation of nature. You should not limit your interpretation of trees, rocks and water to a few learned techniques. In my demonstrations I have selected specific situations and used those methods of paint application that seemed to best express those particular subjects.

I recall a letter from a lady asking if I would be so kind as to tell her how to paint water. I wrote back to tell her that there is no one way to paint it. It would depend on the specific kind of water, the surroundings, the lighting — in other words, on careful observation of the particular scene she wished to paint. Shortly afterward I received another letter saying she found those suggestions so helpful, that would I now tell her how to paint trees?

In this book I'm only concerned with showing some of the ways of using paint and brush to produce various effects. These techniques may be combined, elaborated on or modified to express the character of the objects you wish to paint, not merely as an end in themselves.

A final word on this book. For most of the demonstrations I have included a photograph of the scene I painted, so that the reader may share the sense of being on location and can compare the original scene with my own impression. I do not advocate that the student of painting should work from photos. They are far too limiting. Work directly from nature as much as possible. If you plan to work on a painting in the studio, use photos as a source of information, not to copy.

Painting is an expression of a personal experience, and you must involve yourself with the subject in order to have feelings about it. The things you will study in this book are of the craft of painting. The value of your work is what you have to say about your own impression of the world around you. You can use the craft to put these impressions into visual form.

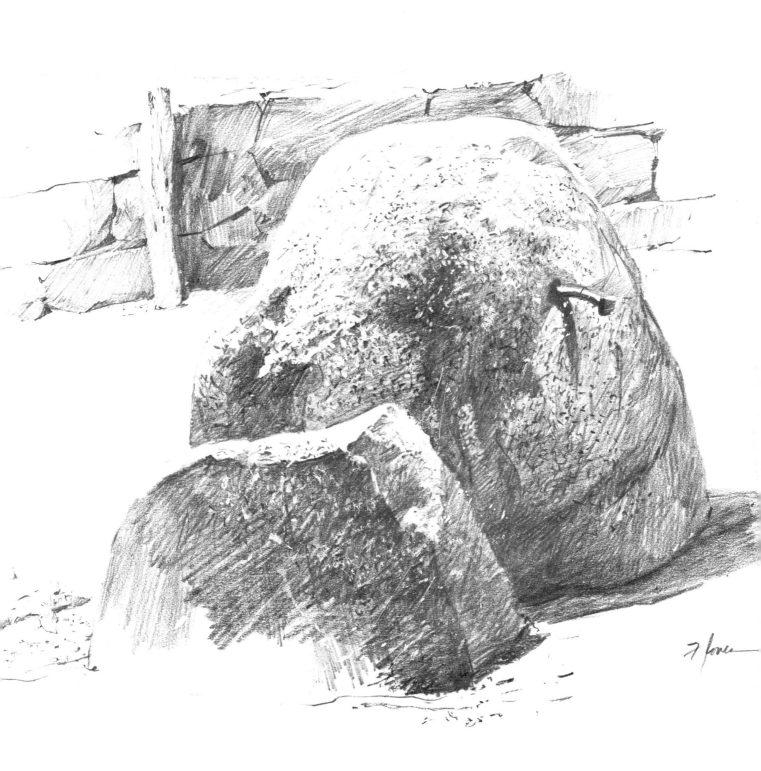

Rocks, 1977. Pencil and opaque white on plate finish bristol.

11

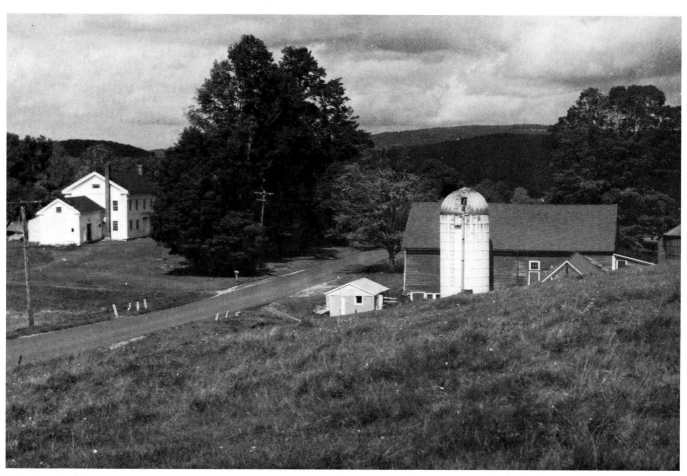

Photograph of the scene

Before you join me in the painting demonstrations I want to talk about the importance of the value pattern, for it is the foundation of all works, regardless of subject or manner of using the mediums. By value pattern I refer to the design of the painting in terms of light and dark shapes that distinguish the elements in the scene.

The reality of nature cannot be put on canvas (unless you want to put sand in the paint and glue tree bark to the canvas). Images exist only because of color and value differences which convey an impression of reality. Therefore, having conceived an idea inspired by nature, the artist mentally, or actually, plans an arrangement of the overall design, distinguishing the shapes of the various areas by giving each a definite value of lightness or darkness. The intent is to describe the objects and to produce a design as pleasing to the senses as a musical composition. Only when the design has been given ample consideration should the artist move on to the actual painting procedure.

The first step in planning the design is to observe the shapes and values that exist in the subject. Compare the lightness of the grass with that of the trees. Compare the lightness or darkness of the buildings with grass and trees. Compare size relationships too.

Having observed these major shapes in the scene, it is then a practical idea to make a small black-and-white study, about the size of those shown on this page, to determine the arrangement of the design within a picture space. Ignore smaller details and concentrate on those shapes that dominate the scene. In these studies you may find it will improve the design if you change some shape, move or eliminate some object or change the value of an area. Usually three or four tones are sufficient to describe the value arrangement of the scene in these small studies.

Planning a painting in this way serves two functions. It lets you see the effect of the subject before starting to put paint on your canvas; and also, as the painting proceeds, it serves as a reminder not to lose the important value relationships as details are added.

These are the kind of rough black and white pattern sketches I find helpful. They can be in any medium you wish. These are in watercolor and are reproduced just a bit smaller than I made them.

I am reminded of the time at Rockport, Massachusetts, when I overheard a young painter say to her companion, who was also painting, "I get 395." A pause, and he replied, "398." Another long pause and she said, "You're right, 398." I had to see what they were doing so I peered over her shoulder. She was painting an old fishing shack, and had nicely established the values of the building, but now she was in the process of indicating each and every shingle on the roof — all three hundred and ninety eight of them — by putting in dark lines to show the separation of each shingle. Her mistake was not in putting in every shingle (though it was of no importance) but in failing to anticipate the value for the sunlit roof. She was making it much too dark by adding all those lines over the undertone. An accurate impression of shingles in sunlight is far more important than rendering every detail in nature.

The opposite approach is shown in the demonstrations on the facing page. Here I have shown how I might alter the facts in order to produce an impression I'm after. In the upper painting I've shown the windows and shutters as they actually appeared on this white building. However, I find it has destroyed my impression of the house as shown in the value study at the top of this page. In the lower painting I've lightened the windows and eliminated the shutters. By ignoring the facts I produced the effect I wanted.

You might have interpreted this scene differently, perhaps seeing the windows and shutters as an exciting pattern in the total design. No two artists see exactly the same thing. That's how it should be. But regardless of our differences in the concept, each of us should design our painting as carefully as knowledge permits in order to express our personal feelings and to achieve a visually exciting statement.

Sometimes I find that a student's mind focuses so intently on the reality of the objects themselves that he or she is quite unaware of light and shadow and its effect upon the subject. Not that sunlight must always prevail in a painting. On the contrary, very often I find the simplicity of the shapes on an overcast day results in a very strong design.

Whether sunlight should prevail in the scene depends on the mood one wishes to convey. But if it is present you should utilize it to contribute to the design. This means selecting a time of day that provides the best lighting arrangement for the particular subject.

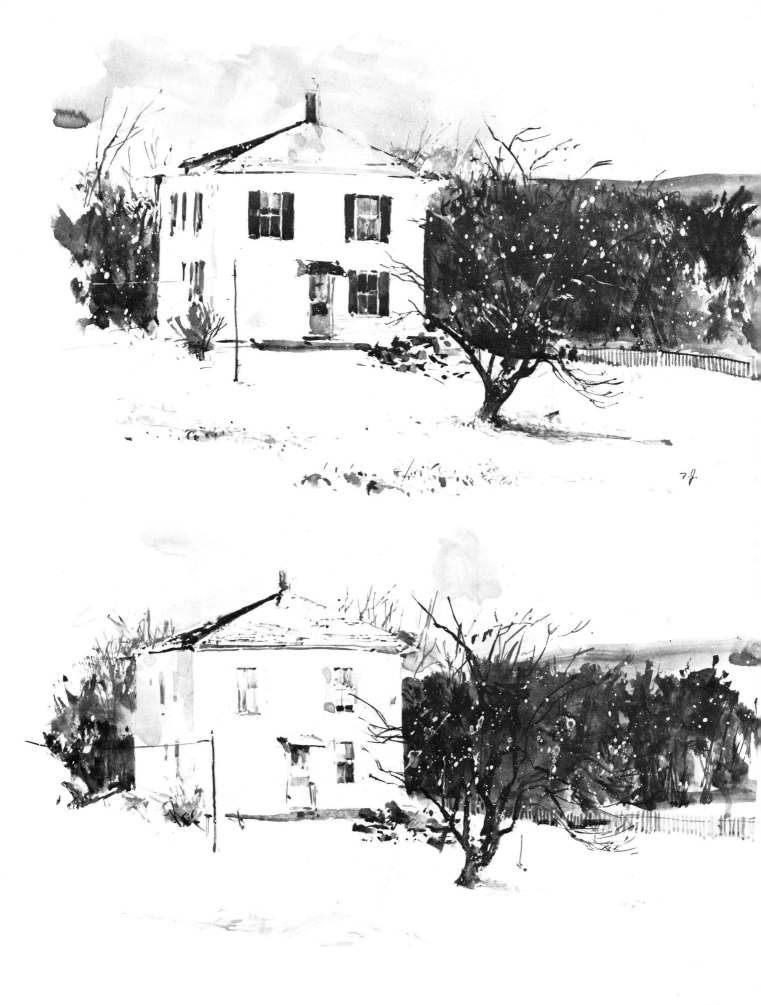

Sometimes I come upon a subject that interests me, but the lighting is such that it doesn't lend itself to a very pleasing design. If it's possible to return to the scene at another time of day I do so. In fact, I may return any number of times if I feel the subject warrants it. In some instances it has been a year or more before I feel motivated to make a painting.

The time of day is not the only factor that influences the patterns of light and shadow on a scene. Consider also the cloud shadows that move over the land, creating ever-changing patterns of light and dark. They can produce very dramatic effects in an otherwise flatly lit scene.

Since these cloud shadows may last for only a few minutes it is necessary to make a notation of them to guide you during your painting session.

One way to do this is to make a small study as quickly as possible, either in pencil or with color. If you concentrate only on the shapes of the shadow areas, you'll be able to record the scene before it changes.

Another method is to quickly establish the shapes of the shadow patterns on your painting. When sketching the scene on watercolor paper I usually outline the shapes of the shadows as well as establishing the objects themselves. For an oil painting I brush in the shadow shapes using dark tones of burnt umber.

To illustrate the point about different lighting possibilities within the same landscape, I've shown some photographs taken at different times of the day and with different cloud shadows.

Even when painting a fully sunlit scene it is a good idea to put in the shapes of shadows as soon as possible. The position of the sun will inevitably change as you work. I've seen paintings in which those areas painted in the morning show shadows on one side of objects while areas painted late in the day show shadows on the opposite side.

This brings up two points to consider. First of all I'd suggest your limiting the painting session to a few hours and returning another day during the same hours. Secondly, it's best to develop the painting as a whole, rather than completing an area and then moving on to another. You'll see in my demonstrations that this is most always the case. I like to think that if I had to stop at any given moment there would be enough indication of all areas so that the painting could be finished at home, if necessary.

Shadows within a sunlit landscape may give the impression of being very dark because of the strong contrast with the lighter areas. However, they are in fact quite luminous because of the reflected light of the sky. Sometimes we are tempted to make them very dark with the idea that it will strengthen the illusion of sunlight. On the contrary, I find the more luminous shadows do this better.

I don't mention this to indicate that you must always make the shadows light. It does depend on

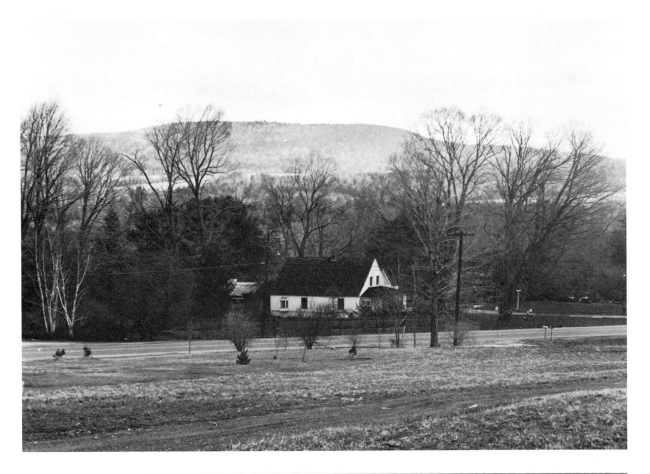

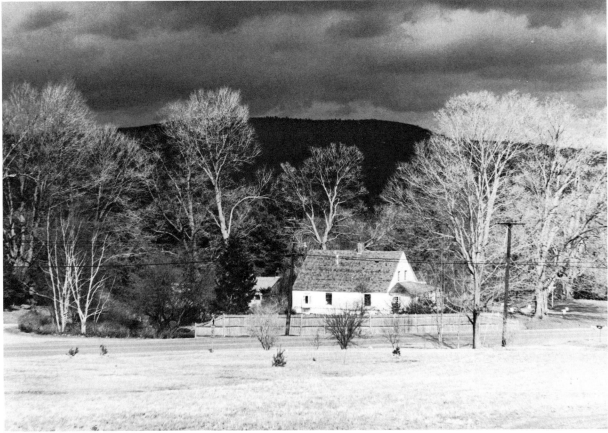

These photographs taken from the same spot show how varied the same things look under different lighting. In the top photo, notice how the roof of the house and the trees merge into the values of the hills and sky, while in the bottom picture the trees stand out starkly in light values against the darker background.

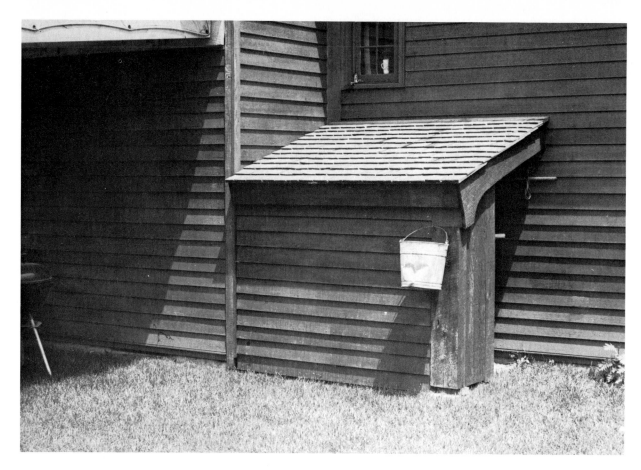

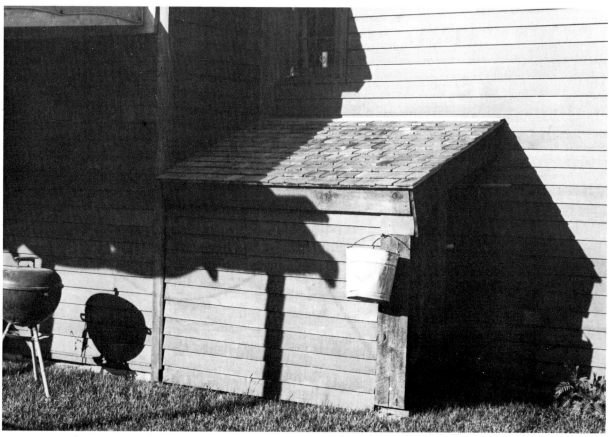

the impression you're after. But it is something to consider in your observations of nature. If you have the opportunity to study a landscape where you can see into an open window or doorway you'll quickly observe the difference between this dark interior value and that of shadows within the outer landscape.

The landscape painter is not restricted to the large expanse of his surroundings by any means. A building, back alley or hull of an old boat are all fruitful subjects for the artist. Or, it may be a more intimate view that catches our eye — an old bucket hanging on the side of a barn, a pile of wood, a tidal pool on the ocean rocks or a Southwest mission wall.

It is in such subjects that I find the play of shadows an important factor, not only in deciding whether the scene should be depicted in sunlight or shadow, but in determining the actual angle of the sunlight that falls upon the scene.

Somewhere in my past I recall such advice as "only paint during mid-morning and mid-afternoon — avoid the light of high noon — sit with the sun at your back. . . ." Perhaps I've taken these statements out of context. So be it. As far as I'm concerned the only limitation is whether it's light enough to see what you're doing. . .I recall that Ed Whitney has painted by candle light.

I particularly remember a striking painting by Ogden Pleissner of some old buildings out West, entitled "South Pass City." The sun is almost directly overhead. The buildings are in complete shadow except for the rooftops and upper edges of the fences. And there is Andrew Wyeth's "Marsh Hawk," in which the sun is so low that only faint rays streak across the land and catch the very tops of buildings — the rest is in quiet shadow. My point here is that you should be alert to the possibilities created by shadows that creep over the face of the land or down the side of a building. Notice, for example, the variations in the designs in the photographs on these pages as the angle of the sun changes.

I find most subjects appealing under any kind of lighting, but landscape painters should be alert to changing light and dark patterns that can effect the picture's design. As demonstrated in these photos, each time of day creates its own ever-changing orchestration of shadow shapes.

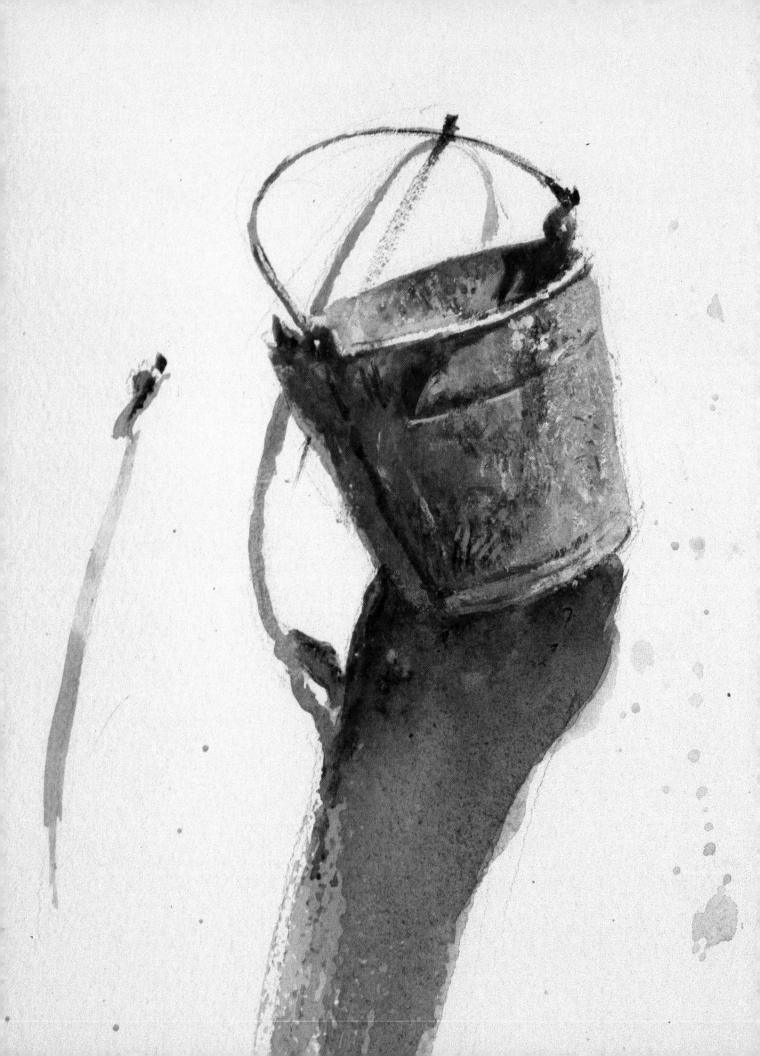

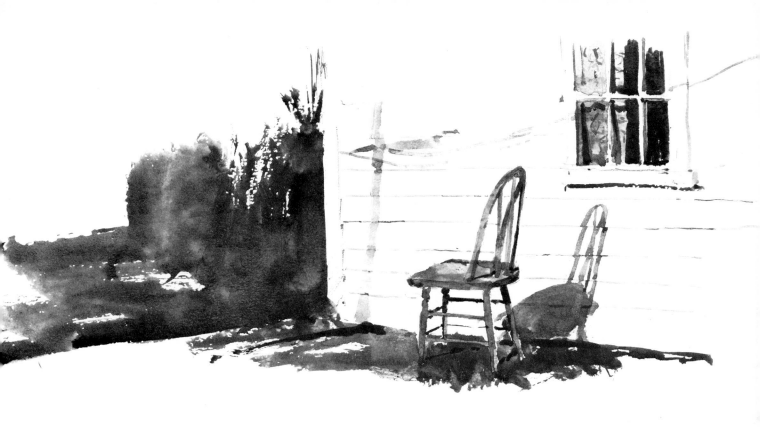

Cast shadows can also provide a sense of movement in the composition; they can direct the eye of the observer through the composition and they can contribute to the feeling of reality in the painting. As they rise and fall across the contour of the surface on which they rest they increase the three-dimensional effect of the form.

Sometimes the shadows may be as important as the objects themselves, as in the studies shown here of the kitchen chair and the old bucket.

Whether or not the shadows should play an important part in the painting depends on the artist's concept. The student often over-emphasizes the shadows in a subject where they are really secondary, by making them too dark. Another common problem is in not paying sufficient attention to their actual shapes. Shadows falling across the ground, for example, are frequently made too deep from front to back, so the ground appears to be on a vertical plane rather than lying flat. Or the shadows may extend so far out from the object that they appear to be a mile long. Careful observation is the solution to these problems, comparing the size and shape of the shadows with the objects that surround them.

As I write, it seems I have expounded long on the use of values and sunlight and shadows. Yet, they are the means by which we see forms about us. The subject is something to which the artist must give considerable thought, for values and sunlight and shadows are the foundations on which color, texture and the paint surface will be built.

When you have found a subject to paint, learn to dismiss the reality of the objects in terms of function and look at them as patterns in a design. That white strip along the edge of a spring field is not snow, but a shape that contrasts in a striking manner against the dark forms behind it. Those are not rocks that rise from the canyon floor, but a rhythmic series of varied shapes in tones of ochre and sienna. For the artist it is not a dirt road that leads to the village, but a gently curving shape that leads the eye through the design. The impression of reality comes later, when the idea has been conceived and the images developed.

Across the Flats. Watercolor, 14 × 29 inches. An example of late afternoon lighting.

Season's End. Watercolor, 22 × 29½ inches. An example of mid-day lighting.

Three Mediums

Before we venture into the painting demonstrations it would be well to briefly discuss the properties of the three mediums I've used — oil, watercolor and acrylic. If some of my descriptions seem quite elementary it is because I will direct them to the new painter who may not have experienced all three types of paint.

Watercolor

Watercolor is considered a transparent medium. In its application the colors are greatly thinned so that the paper shows through the pigment to some degree. The lightness of a color is controlled by the amount of water used in the mixture.

The colors in the painting are not waterproof; therefore subsequent brush work may lift some of the previous washes, especially when the undercolor contains a considerable amount of pigment. For this reason the general procedure is to apply lighter colors first and then to work toward the darker tones.

When it is desirable to apply one layer of color over another, which is frequently done, the latter wash (layer of color) should be applied with a minimum of scrubbing or repeated brush strokes in order not to disturb the underpainting. When covering large areas or for a fluid application of paint, the brush should be well loaded with color. Beginning painters tend to have the brush too dry.

Tube colors are preferred over solid cakes because the pigment can more easily be added to a puddle of water. Another tendency for the beginner is to add too little paint to the water in preparing a color mixture, not realizing that colors tend to dry much lighter than they appear in the wet mixture on the palette. For very dark tones the color should be thinned with only enough water to make it flow from the brush.

A good quality watercolor paper with a cold press or rough finish is recommended for the beginning student. The quality of the paper is almost more vital than a good brush, though both are important. The paint itself need not be of the highest quality, for most student-grade pigments are quite satisfactory.

Oil Paint

Oils are considered an opaque medium. That is, they are generally applied in a thickness sufficient to cover any underpainting. They can be thinned with linseed oil, turpentine, or a combination of the two.

The paint has a buttery consistency that offers a pleasant brushing quality and the slow drying of the pigment allows time for considerable manipulation of the painted surface. It is usually applied to canvas or canvas-like surfaces. I suggest that you apply the paint in thin layers during the early stages of the painting and then build up with thicker layers in subsequent stages. The degree of thickness depends on the artist's personal way of working, though most beginning artists tend to work too thin.

You can complete an oil painting while the entire surface is still wet or you may allow the surface to dry at any stage and proceed over the dry surface.

Oil paints may be left on the palette for a day or two without drying. Turpentine is used to clean the brushes and then they should be gently washed with soap and warm water after each painting session.

An oil painting will generally dry to the touch in a few days or a week if you have mixed some of the turpentine/linseed vehicle into your color mixtures. If you apply some of the slower drying colors without adding any vehicle they may take a much longer time to dry.

Acrylics

While acrylics have been with us for some time now there are still many artists who are not familiar with them. In the simplest terms they are a pigment combined with a plastic and water emulsion. As the water evaporates on being exposed to the air, the plastic particles bond together with the color to provide a hard waterproof paint. The paint dries at about the same rate as watercolor. . .much faster than oil paints. The waterproof character and the fast drying of the pigments allows the artist to work one layer of color over another without picking up the underpainting.

A question I'm frequently asked is whether the drying time of acrylic paint can be slowed down. The answer is that it can be, to a slight degree; but I personally feel that the fast-drying insoluble nature of the paint is its greatest asset. I would use oil colors if I wanted a slow drying medium. There are retarding vehicles available if you wish to try them, although as I've stated, they only slow the drying a bit. If interested in retarding agents, check with your art supply dealer.

Acrylic paints lend themselves to both thick opaque handling, in the manner of oils, and thin transparent washes, as with watercolor. They can be applied to any porous material and possess great durability. The surfaces I most often see used are Masonite, gesso panels and paper.

The type of brush to use with these paints depends on the manner of working. Watercolor brushes are appropriate for thin applications, oil brushes for applying it in a thick manner. There are also Nylon brushes made for this medium, similar to oil brushes in their design.

As I emphasized in my previous book, *The Pleasure of Painting,* it is most important to take good care of brushes when using acrylics. If a brush should dry with paint on it, it will be useless. The best thing to do when not using them, is lay your brushes in a shallow pan (such as a pie plate) with the hairs submerged in water until the end of the painting session. Then rinse them out thoroughly and wash with mild soap and water. Even with care some paint will remain in the hairs and harden in the heel of the brush, eventually ruining it.

In the demonstration paintings for this book I have used the three mediums in more or less traditional ways. Acrylic paints have not been with us for very long, and there are still many approaches to explore with this versatile medium. As I've indicated in previous writings, I do not feel that one should consider acrylic as a substitute for either of the other paints, but as a medium in its own right. But explore all three and find the one that is most comfortable for you. Or, as I do, you may find all three equally enjoyable to work with.

October Apples. Acrylic on paper, 26 × 34 inches.

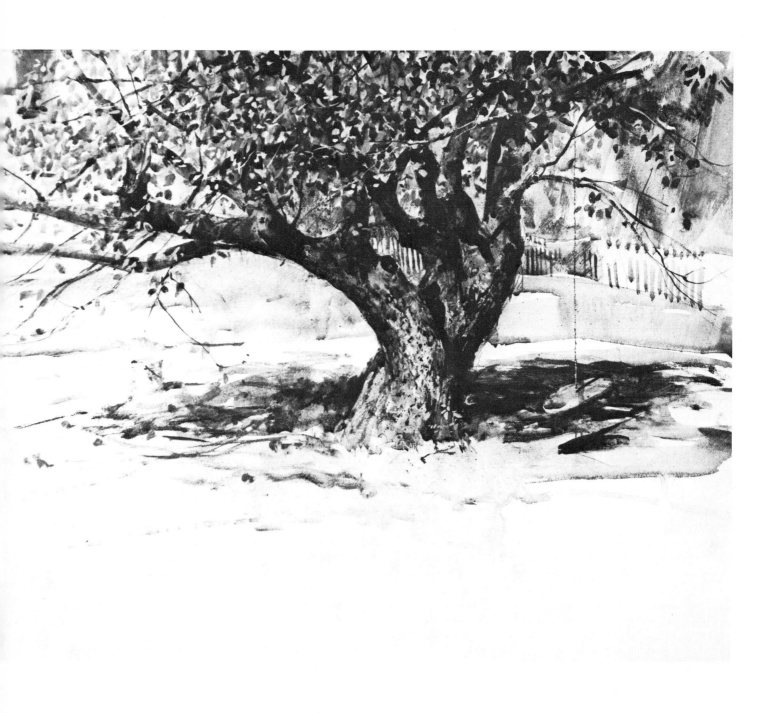

"I think that I shall never see. . . ."

Thus Joyce Kilmer began his description of the beauty that we find in the trees that surround us. The magnitude of species, forms and individuality of this family is so great as to be a never-ending source of material for the artist. The angular thrust of the gnarled oak spreading its branches unrestrained in an open pasture; the graceful rise of the elm with its fan-like spread of branches; the luxuriant foliage of the southern cottonwood; the magnetic thrust of the mighty sequoia. . .these are but a few that come to mind.

More frequently the artist uses trees in conjunction with other landscape elements. They provide a contrast for the geometric forms of buildings or the flat expanse of a field or pond. As a mass they serve as a background against which other forms may be silhouetted.

In my own surroundings in the Berkshires I'm fortunate to have trees of every description. Glancing from the studio window at this moment I see pine, hemlock, spruce, aspen, hickory, apple, willow, birch, a variety of maple and countless others I don't know by name. In this early stage of winter the hills are a solid carpet of tree tops extending as far as the eye can see, soft and furry in delicate tones of gray and rust.

While it isn't necessary to learn the name of each tree, it is important for the artist to be aware that each type has its own characteristic and to carefully observe them when painting. Observation is the key to painting convincing trees. It is my opinion that they are the most neglected forms in student paintings. The reasons are probably many. They are frequently complex in structure compared to other elements in the scene. They vary in form to such a degree that we may assume any mass of green will adequately suggest foliage, and any linear strokes will suggest branches. Or perhaps we are so familiar with their presence that we don't feel the need to look closely.

I recall mentioning to a non-painting friend that I must look for a tree to paint for my book.

"What!" he said, "you're an artist and you don't know what a tree looks like?" Well, for me, painting a tree without looking at one is like doing a portrait without observing the person. Each tree is a personality, not a generality.

Sometimes a student in my class will cry for help. "I can't get the trees to look right." After studying his painting I'll glance around the room as though searching for the subject he's painting.

"Oh, they don't exist," he'll say. "I'm just making them up," as though I didn't know. I remind him that if he'll look at real trees he'll probably have no trouble getting them right in the painting.

In learning to observe the tree structures you should first look at the overall shape as a silhouette. Then study the angle of the limbs as they extend out from the trunk. Finally observe the character of the foliage. The silhouette of a pine is different than that of a hemlock. The structure of the limbs of one type of maple is different than that of another.

It is helpful to know what the skeleton of a tree is like, even though you may be painting it in full foliage. I make pencil studies of various types during the winter months and then do the same when they're in full leaf.

In painting the individual tree when it is bare of leaves, look for tonal changes up and down the trunk, rather than having it all the same color and value. The same with branches. Note that some are darker than others, influenced by the light direction. Note the tapering of the trunk and limbs as they extend out. Also look for those branches that extend out of the face of the trunk toward you. There's a tendency to show only branches that extend to the sides.

When the tree is a major element in your painting, observe the lighting to see if it is interesting and helps describe the form.

When painting foliage, study the shape and tones of the mass before being concerned with the indication of individual leaves.

The degree of detail that you need to show in the foliage or the tree trunk depends on two factors.

In a pencil drawing such as this, trees play a secondary role and should be kept simple. Their main function is to serve well in the composition and help establish the proper environment. Notice how simply the two trees on the extreme left are stated.

The first is whether you intend to work in quite a detailed and refined manner throughout the painting or in a broad impressionistic manner. The second is whether the tree is nearby or some distance from you. Trees at some distance should be treated quite simply in order to convey an impression of depth in the scene.

It's amazing, and often confusing, how much the eye can see if we stare at a single spot in a landscape. We may be able to see the individual twigs on the crown of a winter tree. However, in a more cursory look at a landscape, this tree top will appear as a soft blurred tone. It is more usual that you will want to paint it as the latter because that's the impression in the mind.

A final consideration before we move on to the demonstrations is color. Tree trunks are not necessarily brown. They may be of various tones of gray, from blue through green to ochre and sienna. Frequently all of these grayish colors will appear in a single tree.

Foliage is not all of a single green; seldom a bright green. Look for blue greens, yellow greens and red greens. Compare the greens of one tree with another and you'll find it easier to recognize the great difference.

Learning to see the subtle colors of nature is a matter of constant observation. Compare one area of foliage with another. You might see that one appears just slightly more red or orange than another. It isn't a distinct difference — almost an imagined thing. You feel it will disappear if you stare too long. But go by that first impression and adjust your green mixture with a bit of the color you feel is there.

One does not have to match the colors of nature, of course, for again I stress that painting is a personal expression motivated by our observations. One artist may interpret a scene with brilliant hues while another expresses it with a limited range of muted color. But an awareness of that which exists in nature will provide you with the material from which you may express your own ideas.

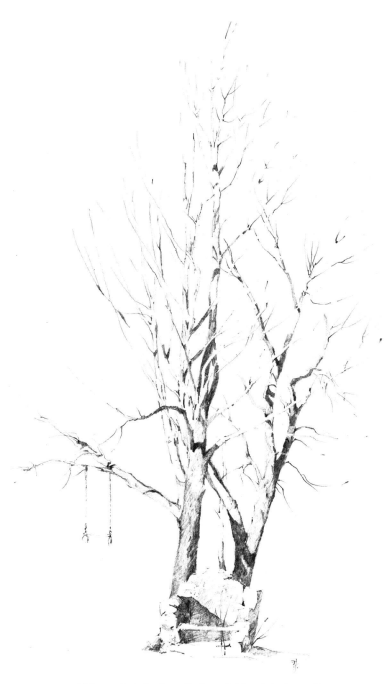

This pencil study shows the busy light and shadow patterns apparent on the leafless limbs and trunks under a bright winter sun.

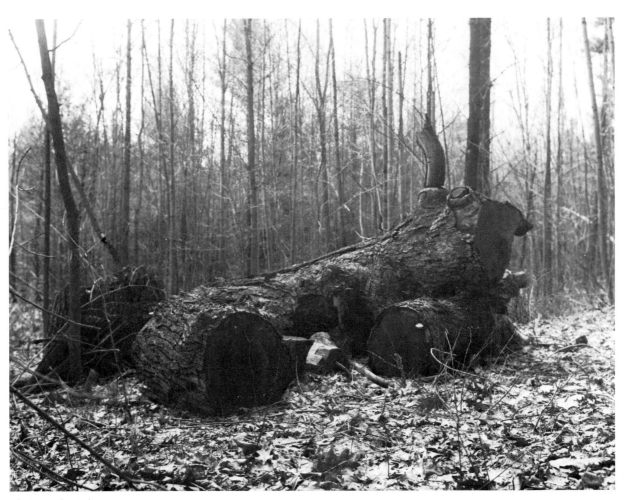

Photograph of the scene

Demonstration 1
The Fallen Tree
An acrylic painting

Wash study for The Sage. Watercolor on smooth bristol paper.

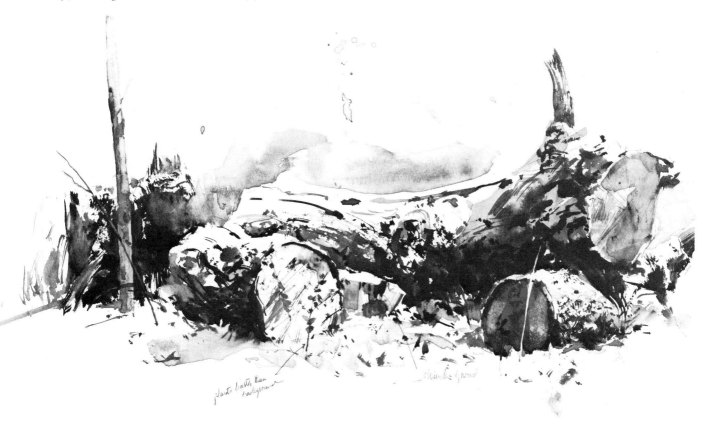

This is the second large painting I've done of this old tree trunk, in addition to having made numerous pencil, watercolor and acrylic studies from various views. I find it a fascinating subject in shape and texture. I've included backpackers (**page 34**) because of association; the tree had fallen directly across a woodland trail frequented by hikers and had to be cut into smaller sections in order to clear the trail. Another purpose in using the figures was to give scale to the tree.

In describing my procedure for painting this particular subject, I thought it best to begin with the steps that preceded the painting itself. This will provide an insight to my methods when completing a piece in the studio.

I highly stress the need to work directly from nature whenever possible. It is the best training. But for large acrylic paintings in which I plan to spend considerable time refining the subject I will make smaller preliminary color studies, pencil drawings and take a number of photographs. These, plus my memory of the scene, will serve as later reference in the studio.

For the painting in this demonstration I used a ⅛ inch Masonite panel as the support, which had been given four coats of acrylic gesso applied with a foam rubber paint brush. This gives a fairly smooth surface with a minimum of brush marks. I didn't sand the surface, although this may be done if one feels the need for a perfectly smooth surface.

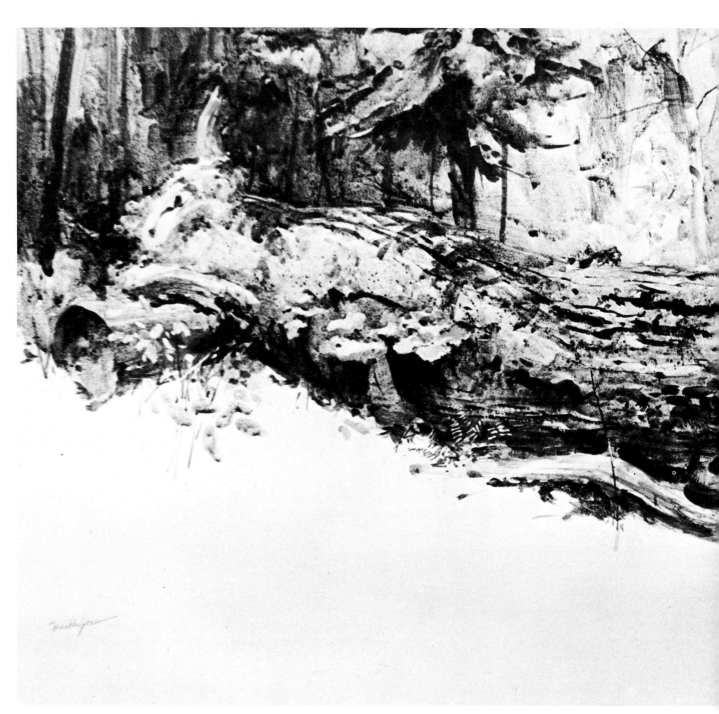

Study of The Fallen Tree. Acrylic on paper.

My palette contained the following acrylic colors: burnt umber, Hooker's green deep, yellow ochre, cerulean blue, cadmium yellow light, cadmium red light, mars black and titanium white.

My brushes consisted of a #6 and #9 round watercolor brush, a ⅝ inch flat watercolor brush and #0, #4 and #6 bamboo brushes.

For a studio palette I use a 12 × 17 inch enameled tray called a butcher's tray. I put out only those colors needed at the particular stage of the painting.

Preparation: Having selected a time of day that gave a lighting effect I liked, in which the figures would be more or less silhouetted against the background, I first made a black-and-white wash study of the tree trunks. This was followed by a small watercolor painting of the same scene (left).

I next prepared a number of small black and white composition studies in which I included an indication of the figures. These studies established the arrangement of the elements within the picture space and the proportions for the final painting. One of these studies is shown at the top of page 34.

Next, I had someone pose for me under the same light conditions and took photographs and made sketches of the model in various attitudes. It's a good idea to record a number of poses when having someone model for you, in case you find the original idea doesn't seem just right.

When I was satisfied with the composition and had gathered most of the information needed, I moved into the studio.

The next step was to determine the size for the larger painting and the Masonite panel was cut to the proportions determined in the small study. I made the panel 26 × 38 inches.

The small study was then scaled up to the larger size and the scene lightly penciled onto the panel. Sometimes I might square off the small study with a grid of horizontal and vertical pencil lines and then do the same with the larger panel. In this way the grid serves as a guide for copying the small sketch. In this instance I made the larger drawing by eye on a separate sheet of tracing paper. This was then transferred to the panel.

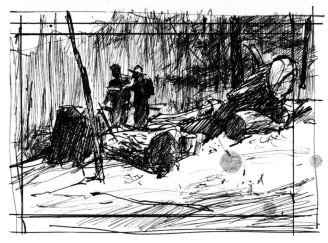

My thumbnail compositional sketch was done with pen and ink. At this scale, the light and shadow pattern can be quickly worked out.

Stage 1:

With my drawing lightly indicated on the large panel I prepared a mixture of burnt umber and a little mars black, thinned with a little acrylic painting medium.

Note: *The painting medium is a milky liquid used for thinning the paints or varnishing the final painting. I use either the medium or water to thin the paints, depending on the fluidity desired in the brush work. The medium gives a more creamy consistency to the mixture than water.*

The dark mixture was applied to the sides of the tree trunks by pushing and twisting the brush against the surface, thus leaving the impression of the strokes Textural effects can be used at this stage because I intend to work over them with transparent color and they will show through in the final painting. At least some will. Others may be hidden as I proceed. While one of the purposes of this initial painting is to establish the values of the painting, I like to take advantage of these accidental effects that I might achieve while putting them in initially.

This same color was used to put in the vertical tree on the right. Note that my colors were lightened by painting thinly rather than by adding white to the mixture. Adding white would cause the color to be a single smooth tone.

Next, a mixture of green and a bit of umber, not thoroughly mixed, was scrubbed over the upper part of the painting. The green and brown tones varied because of the loose mixture. Although figures were not covered by this green tone, they could have been, since the pencil lines would show through the thin color.

With a darker green I put in the cast shadow under the right end of the log.

Next, with a mixture of yellow ochre and umber thinned with water, the ends of the smaller logs were painted. The color was scrubbed vigorously as I put it down, causing it to bubble a bit, providing a different textural effect. This same color was used for the chunks of wood lying between the smaller logs.

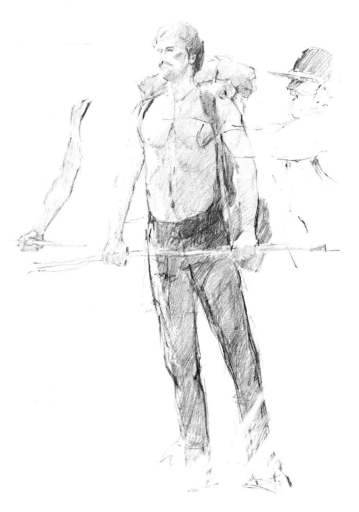

When figures are prominent in the picture, I find it advisable to do preliminary studies such as this. These help solve the construction and action problems and makes the final painting easier.

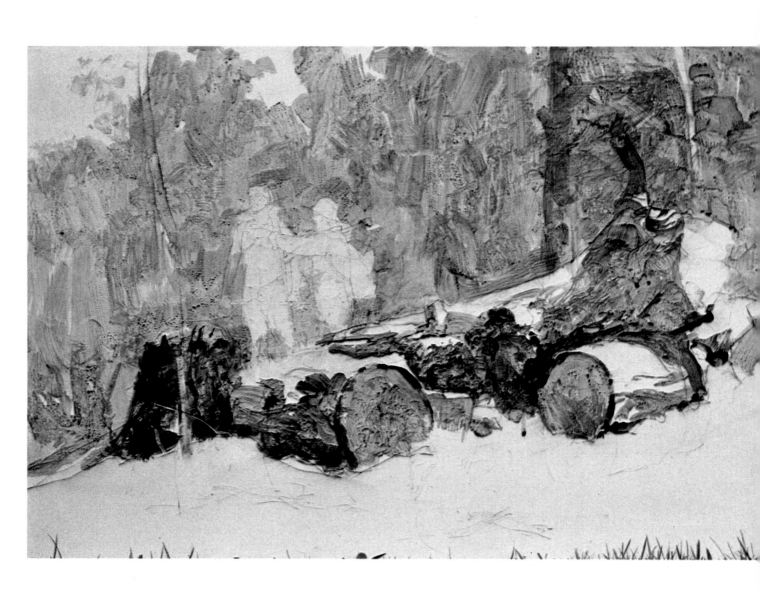

Stage 2:

A thin fluid mixture of yellow ochre and umber was brushed in over the foreground in front of the logs. This was just to establish a rough tone for the area, which will be developed later. Similarly, some dark tones were added along the bottom.

Even at this early stage there is a fair indication of the tonal pattern of the overall painting. To complete the general lay-in I next roughly painted the figures, not trying to be too specific yet.

Now, ready to build and refine the various areas,

I added a few more tree trunks to the background. Then I felt this background should be softened a bit to give a greater feeling of distance, so a thin bluish mixture with a little white added was brushed over most of the area. The white in the mixture gave a soft hazy quality to the color.

More tree trunks were added on the right side and the single thin dark tree was put in on the left.

Next, a slightly more opaque mixture of a bluish color was used on the logs to establish a middle value between the lightest and darkest areas.

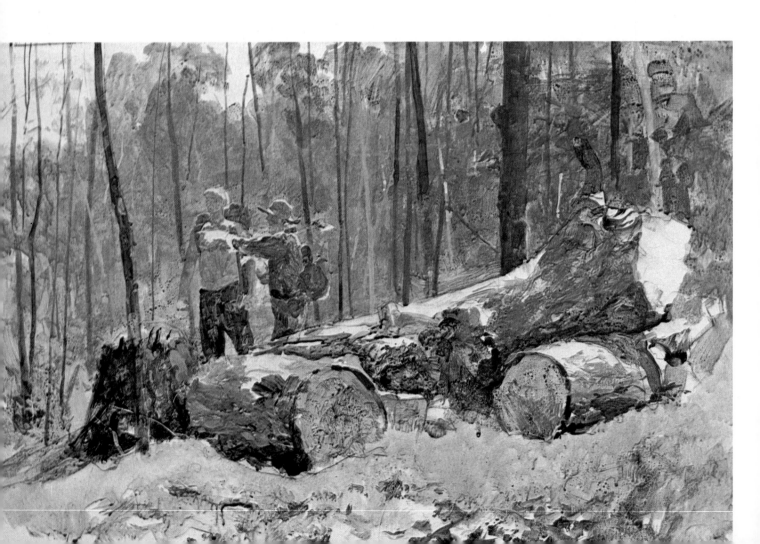

This enlarged section of the painting shows the
feeling of roundness that begins to appear on the
logs as I establish the three values. Here, also, the
textured effect on the end of the log is more evident.

Stage 3:

The painting has taken on quite a different appearance with additional refinements. The painting begins to pull together.

First, a thin transparent glaze of burnt umber was brushed over the entire surface of the logs to give them a warm tone and to unify the light, dark and middle values.

Over the glaze I added thin dark strokes to indicate the grooves and other dark notes on the rough surfaces. I did not attempt to copy nature but rather put down my impressions of what I saw. Next, I filled my brush with umber thinned with water and spattered some areas with this dark color. To produce the spatter I tapped the handle of the brush against my wrist while it was poised above the logs. These specks of color add to the rough appearance of the old tree trunk.

I now completed the right end of the large log in the same manner used on the ends of the other pieces.

At this point I spent considerable time carefully refining the two figures, using my photographs as reference. The painting was done with both transparent and opaque color. When I had completed modeling the forms, I applied a transparent umber glaze over the shadows, both to unify and darken the colors.

Next, with pale green mixtures of opaque color the small individual leaves were added to the background. The scene is of spring, and so I try to keep the indications of foliage light and delicate.

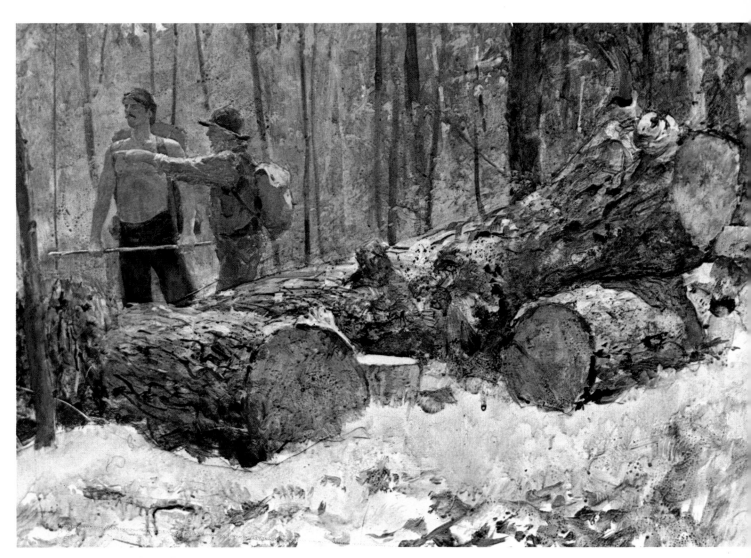

Detail of partially completed painting.

Stage 4:

The foreground in this instance was left undeveloped until the last stage, though the initial tone in this area allowed me to judge the overall painting in terms of tone and color. Then I began to develop the impression of fallen leaves on the ground. This was done in a series of steps.

First, with an opaque tan color mixed from white, cadmium red and yellow ochre, numerous small strokes were applied in a manner to simulate scattered leaves.

When these tones had dried a very thin glaze of burn umber and yellow ochre, thinned with painting medium, was applied over the entire area.

On top of this I immediately added more of the opaque paint, varying the color a bit as I indicated more of the individual leaves. These strokes were scattered over the area, leaving some of the underpainting showing through.

Once again I applied a glaze of umber and ochre over the entire area. The first tones that had been applied now appeared darker than the later brush work, producing a variety of tones and color.

This same procedure was repeated a third time and I also added some small twigs and a branch scattered among the leaves.

Then I put in the small green leaves sticking up among the dead ones.

Now I was ready to put in the finishing touches throughout the painting. Some light opaque color was added to the top planes of the logs; small plants were added in the vicinity of the logs; a bright metal cup was put in on the backpack and other highlights were strengthened on the figures.

Finally, very thin dark branches were added to the background trees and the painting was complete.

The Sage. Acrylic on Masonite, 25½ × 37½ inches.

Notice how the overpainting and glazing of ochres and greens have softened the values and given the final painting an overall cooler and more subtle tonality than apparent in the preliminary stages.

Photograph of the scene

Demonstration 2
Tree in Summer

An oil painting

During the previous winter I had made a drawing of this maple tree on a farm not far from my studio. Now, on a hot, hazy afternoon in late summer I decided it would make a good subject for a demonstration of painting foliage.

The painting was done on a 16 × 20 canvas panel. This is canvas glued to a cardboard backing. While it doesn't have the nice feel of a stretched canvas it does work well for smaller paintings, and panels are convenient for carrying on a painting trip.

The following colors were used in this painting: burnt umber, burnt sienna, alizarin crimson, cadmium red light, cadmium yellow pale, yellow ochre, thalo blue, cerulean blue, viridian and titanium white.

My brushes were a #4, #7 and #8 flat bristle, a #3 bright bristle, a #4 round bristle, and a #3 round sable.

I might point out here that some artists prefer to tone the canvas before starting to paint. This is usually done with burnt umber, although any color might be used. The easiest procedure is to dip a rag in turpentine and then into the oil color and rub this mixture over the entire surface.

The purpose of toning is to establish a middle value which makes it easier to judge the initial applications of color. Toning also helps avoid having pure white canvas show through any areas where the surface may not be completely covered during the painting process.

In my own work, as you'll see, I sometimes do and sometimes do not tone the canvas.

Pencil study made in winter.

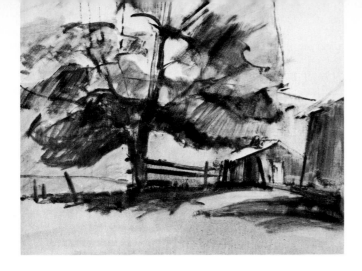

Stage 1: (Small photo) The scene was sketched directly on the canvas with sienna using the #3 bright bristle brush. (Bright brushes are square tipped but have shorter bristles than the flats.) Then I scrubbed in some sienna tones for the darker areas of the scene using a #7 flat brush. This was done just so I could see the general appearance of the composition and establish the shadows.

(Larger photo — opposite) I began painting by putting in a blue-gray color for the distant hill using a mixture of white, cerulean blue and umber. In this case I started with a light color because it will be easier to paint the darker foliage over the background.

Next, with dark green mixtures of thalo blue, cadmium red and yellow ochre I roughly established some of the foliage.

Then, I put in the dark red of the larger building, using alizarin and some of my green mixture. The smaller building came next and finally the ground areas.

Stage 2: I put in the sky, in anticipation of adding the foliage over it. The color used for the sky peeking through the foliage is slightly darker than that used on the far right. The reason for this is that a small area of a light color surrounded by darker color will appear even brighter. This would cause these sky holes to pop out too much unless they were slightly subdued.

I went back over the distant hill with subtle color and value changes using smaller, more vertical brush strokes to create an impression of the tree-covered hillside seen through a heavy haze.

Next, I established the shadow under the tree more clearly and proceeded to develop the foreground. This was done with fairly thick paint using my larger flat brushes. The color mixtures were varied as I proceeded, and the direction of my brush strokes defined the irregular contour of the ground.

At this point I put in the fence gate on the left and then worked on the small building, establishing stronger darks for the shadows with relatively thick paint and using even thicker paint for the sunlit areas.

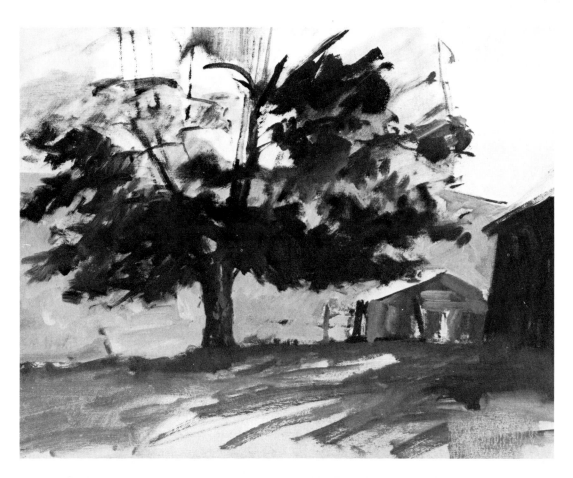

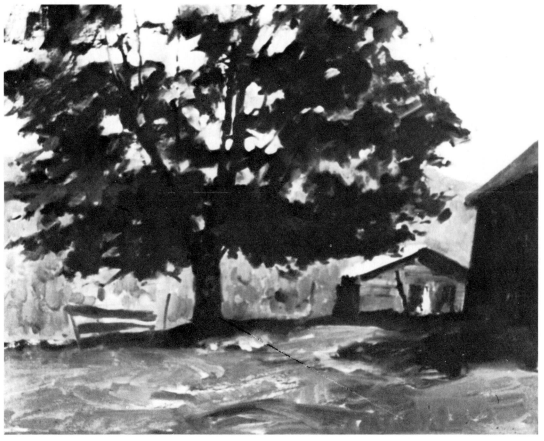

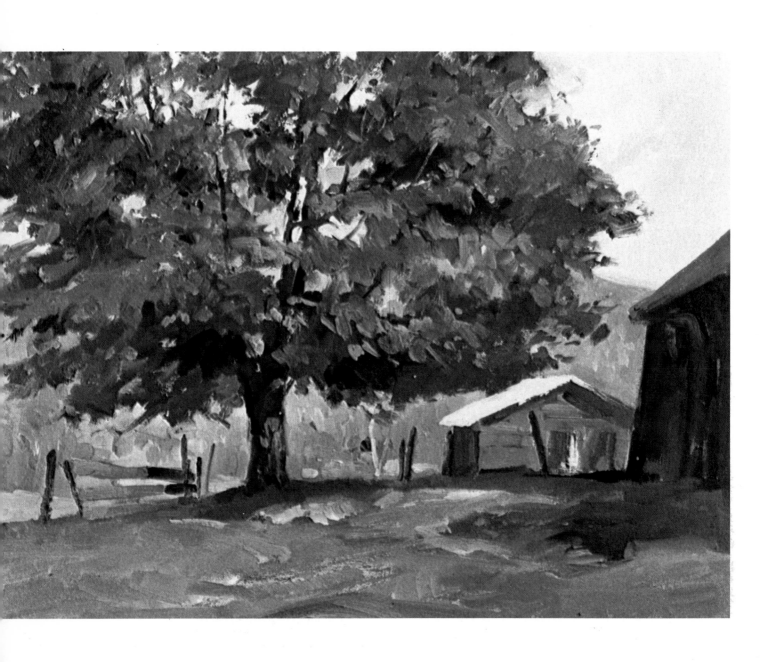

Stage 3: You will note that I did not restate the dark horizontal boards under the tree. At this point I realized that there were already too many forms along the crest of the land, blocking the viewer's eye from moving comfortably back into the scene. By leaving out the dark fence I hoped to open up a pathway into the distance.

I now concentrated on the foliage, putting in the middle values with slightly lighter, warmer variations of green. These mixtures contained more ochre and cadmium red combined with viridian rather than the darker thalo blue. This foliage was put in with smaller shapes than used for the previous darker masses, and they are concentrated more on the upper planes of the larger masses, especially on the right side of the tree. This area faces more directly toward the sun, which is overhead to the right.

I put in the cloud with a pale mixture of pale yellow, ochre, and white, before adding the foliage along the edge of the tree.

Then I shifted my attention to the fence gate on the left and developed this in more detail.

Summer Shade. Oil, 16 × 20 inches.

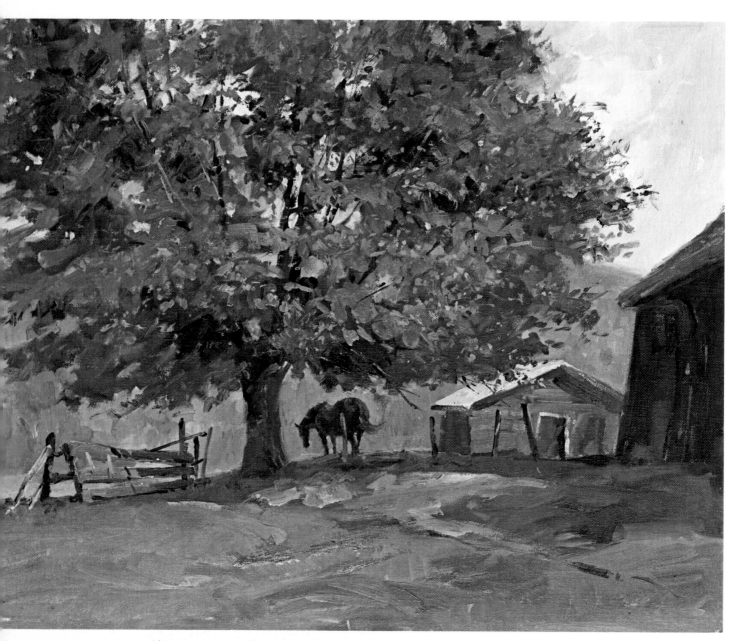

After the painting was finished someone asked me what the red dots were in the tree. These small areas are merely the sienna underpainting described in stage I, showing through. I felt no need to cover them all as they give the foliage a touch of warmth that seems desirable.

Stage 4: At this point a horse wandered up from the back pasture and took shelter in the shade of the tree. I thought she might provide a focal point for the painting and so I put her in. This provided a little interest in the painting, but now it was even more obvious that my composition was quite static. Too many individual shapes were lined up across the middle ground, and there was no sense of movement or unity in the design.

I stopped and made the small composition study shown below. Reducing the size of the small building, tying the horse, tree and dark fence together as a unit, and having the horse's head direct the eye into the distant field seems a much better design.

But I decided to complete the painting already in progress and save my study for another day.

Using variations of warm greens I built up the lightest planes of the foliage. First, I used my smallest round bristle brush for the darker of the strokes. Then I used my small round sable brush for the more distinct leaves within the masses of foliage and along the right edge. Some leaves were put in over the light roof of the building to help set the building back.

There is not a strong separation of light and shadow planes in the foliage because it is so broken up by light and shade of each leaf that the total impression is one of soft transition.

A little more work on the fence and small building, and the painting is complete. You might want to try your own version of this scene, using the small study for the composition.

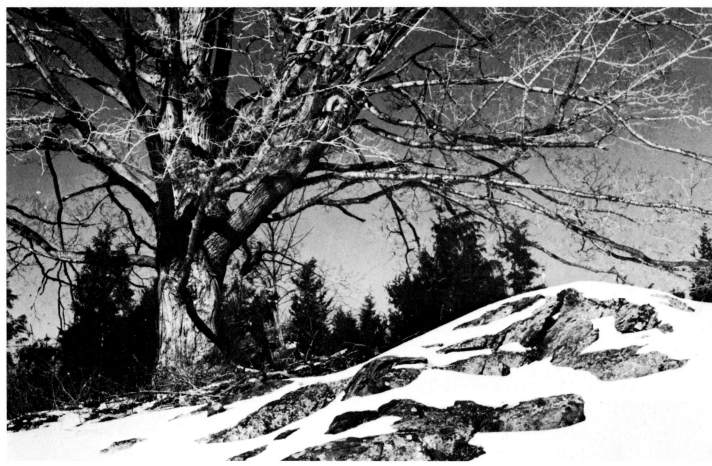

Photograph of the scene

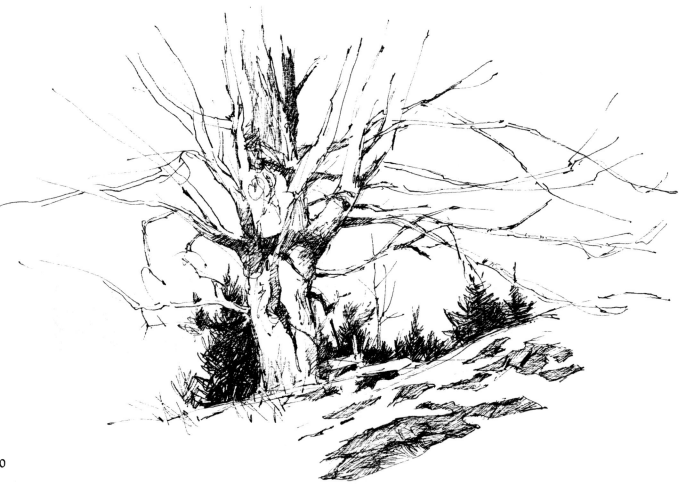

Demonstration 3
The Bare Tree

An acrylic painting

Our dear friends, Marty and Kit Sagendorf, had just bought an old Victorian type home in Bridgewater, Connecticut and we drove down to see it. While outside sketching the house, I noticed the big maple sitting up on the crest of the hill. I climbed up there, made a pen sketch and took some photographs of the branches and rocks for detail information. The painting was done in the studio.

This was a fine speciman of an old maple with its wide spread of branches. In this instance I recorded the tree pretty much as it appeared. In a few minor areas I eliminated or altered those branches that might be confusing, or where inappropriate for the outward thrust of the movement I wanted. On the right side of the tree, for example, a number of branches came together in a tight overlapping arrangement. In the painting these were separated in order to avoid any confusion as to their structure.

I mentioned earlier that the work in this book would be painted in the traditional manner of using the medium. But acrylic paints are still new, and there is no tradition set. I like to explore various approaches, and the one used here might be something you'd like to experiment with.

For this painting I worked on a sheet of rough Bainbridge illustration board.

My acrylic colors were burnt umber, thalo blue, yellow ochre, cerulean blue, cadmium red medium, Hooker's green deep, mars black and titanium white.

I used a 1½ inch flat watercolor brush, a #6 and #9 round sable and a #00 and #3 bamboo brush.

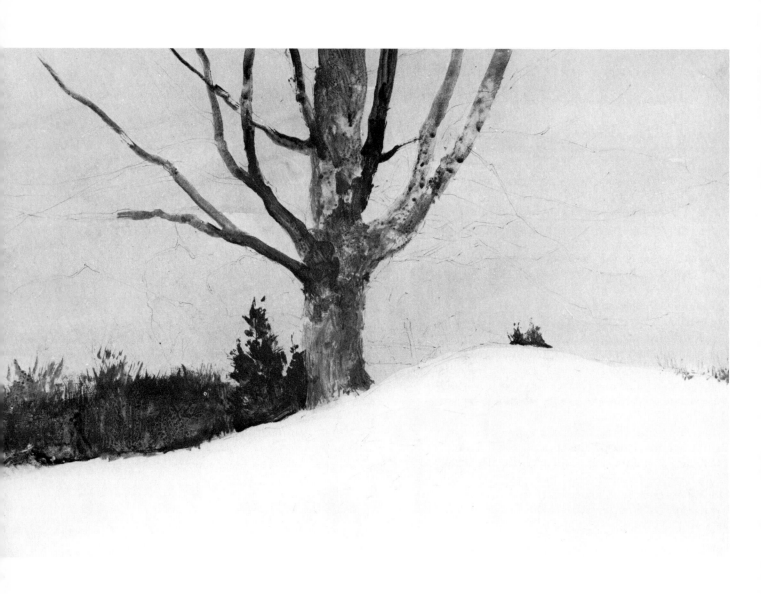

Stage 1: I sketched the scene directly onto the illustration board with pencil. Then I prepared a very pale mixture of black and yellow ochre thinned with water. This was boldly brushed over the entire sky area exactly in the way one would use watercolor.

When the color had dried thoroughly (I used a hair dryer to help it along) the entire sky area and the rocks were given a coat of acrylic glossy medium.

The purpose of this approach was to first achieve a watercolor effect on the paper, then seal it to provide a slippery hard surface for the subsequent painting. The slippery effect causes the paint to behave something like finger paints, allowing for manipulation of the color on the surface. While the color is still wet, it can be wiped off quite easily for changes. Once dry, it adheres to the surface.

When the glossy surface had dried, I proceeded to lay-in an undertone for the tree trunk and main limbs using varying mixtures of black, yellow ochre, thalo blue and white.

Next, using my larger bamboo brush, I put in the evergreens to the left of the tree, using a mixture of Hooker's green, umber and ochre. The smaller evergreens on the right were also put in since the color was already mixed.

Then, using the same brush, the distant woods on the left was established. By pushing the brush into the sky area it was easier to achieve a rough edge for the tops of the trees.

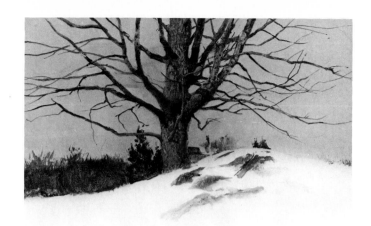

Stage 2: I went back to the main tree, putting in the undertone for the branches. The darker ones were put in first, primarily with burnt umber. Then the lighter ones were added, using color mixtures that contained some white to make them opaque. Thus this color covered the darker branches where they overlapped.

The color and value of the branches varied according to my impression of the scene and the effect I wished to achieve. Although I've tried to make this painting quite descriptive of the actual tree, there is no attempt to copy the exact details of each branch or to put in every branch. What I do strive for, though, is to get an impression that the branches extend from every face of the tree. . .not just out to the sides.

At this point I wanted to emphasize the general lay-in of the shapes and approximate values of the scene, so I prepared some gray-green color from Hooker's green, black, umber and white. With thin applications of this mixture I established an undertone for the rock outcroppings in the snow covered hillside.

With the overall value pattern roughly indicated, I could now proceed to develop the individual areas, beginning with the tree since it is the main element in the painting. This was done with various tones of color, building one over the other from dark to light or light to dark as the need arose, although primarily I proceeded from dark to light.

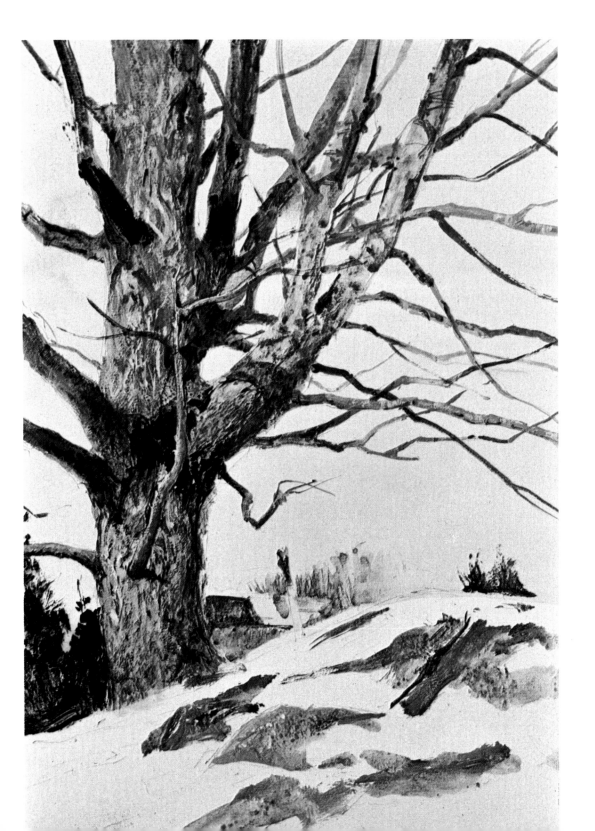

Stage 3: I continued to work on the tree, adjusting the color and value of each branch. While I have not tried to actually model each branch to show its roundness, I have used value changes to show the effect of light and shade along the surface.

I mentioned earlier that a tree is painted in the same order that it grows. That is, begin with the trunk, move up the main limbs and on out to the extremities. That's the procedure I used here, and so I was then ready for the smallest branches and twigs. Without some indication of these, the impression will be of a dead tree rather than one simply dormant for the winter.

I used my smallest brush to put in a sufficient number of these little branches. Again, it isn't necessary to put in every one that exists. I used light opaque color where these branches overlapped the dark areas of the tree and darker umber strokes for those against the light sky.

I next moved to the rock forms in the snow. First I went over them with more transparent glazes of gray mixed from black and ochre. Over this I put in some opaque white to indicate the patches of lichen. More transparent color followed, to tone down the white. Next I dragged some white lightly over them with a very dry brush. This provided a rough texture for the rock surface. Another transparent glaze of color went over this.

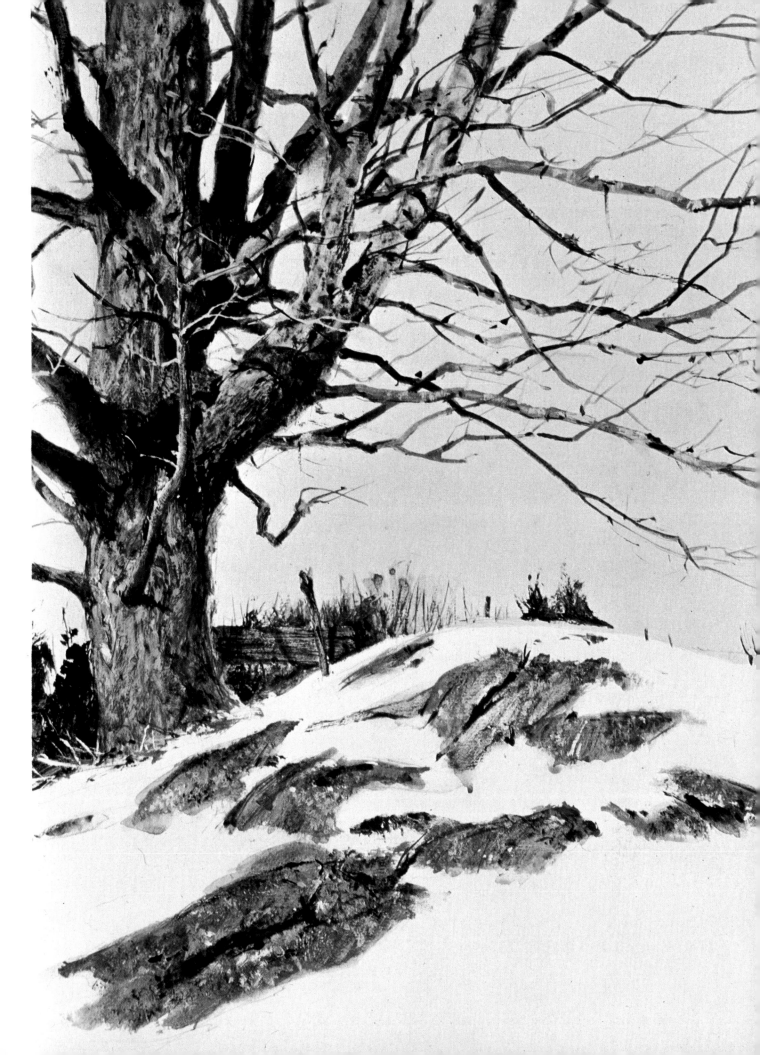

Stage 4: The next area that I refined was the mass of distant trees on the left. First I applied some thin vertical strokes of a light ochre color over the darker background. Then, with dark umber, I put in some more-distinct trees, extending the thin branches up into the sky.

Ready for the snow, I used white paint applied thickly enough to cover any undercolor. This enabled me to define the top edge of the hill and the exact shapes of the rocks. The entire area was covered with the white paint which was slightly warmed with yellow. A delicate gray was added in the upper right area to show a change of tone on the far side of the hill.

Next, some warm color was used to suggest the leaves showing through the snow among the rocks and at the base of the big tree.

A fence post was added on the far left. At this point I decided to bring out the shape of the old piece of wood near the tree, so I lightened the background trees in that area. Also, I put in the cast shadow of the limb that's coming directly toward us from the face of the tree trunk.

A final adjustment was to lighten the more distant pieces of rock to increase the sense of depth to the hillside. I also reduced the textural indications on these pieces of rock for the same purpose.

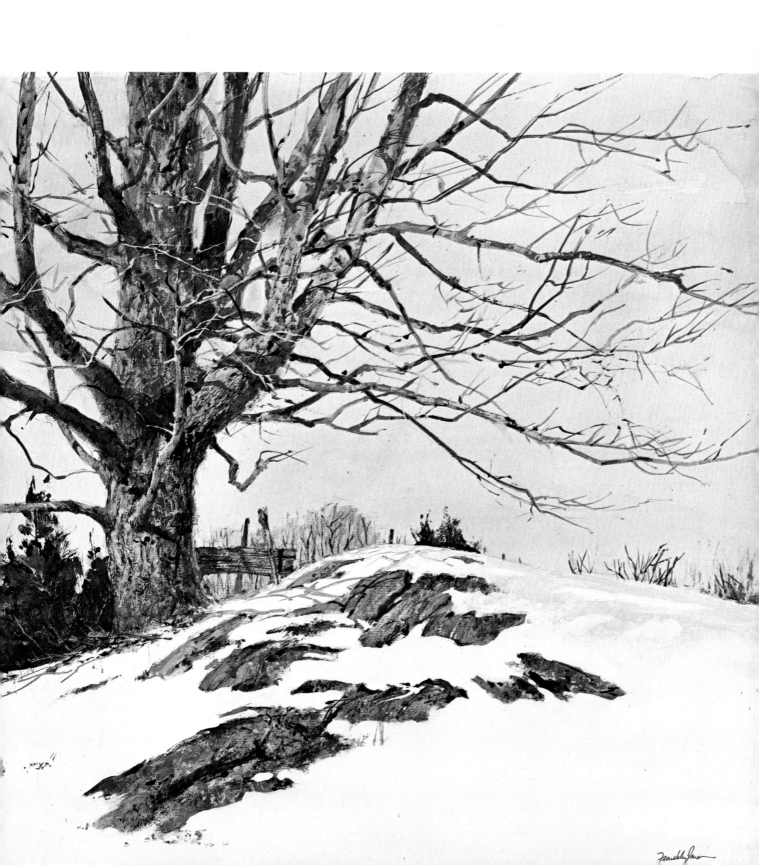

King of the Hill. Acrylic on illustration board, 19 × 29½ inches.

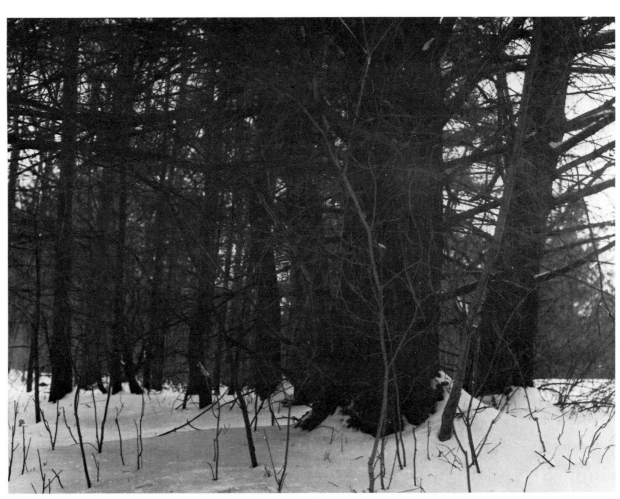

Photograph of the scene

Demonstration 4
Woodland

An acrylic painting

I bent low to avoid the overhanging branches of some pines as I started into the woods. From this crouched position my eye caught the interesting pattern of dark shapes thrusting upward from the white ground. The soft light of the overcast day caused no harsh shadows, and the simple flat expanse of white emphasized the dark shapes. The criss-crossing of the smaller branches wove the dark forms together. I liked the simple beauty of this scene and went back home for my painting equipment.

For this painting I used acrylics in the manner of watercolor, working on a sheet of 300 lb. rough watercolor paper. I made no preliminary studies, sketching with pencil directly onto the paper.

The long horizontal shape was suggested by my impression as I first surveyed the scene from my crouched position.

Although I did take some small advantage of the particular qualities of acrylic, this painting could have been done with almost equal results with watercolor.

My brushes consisted of a #6 and #9 round sable, a 1½ inch flat sabeline and a #3 bamboo brush.

The colors used were as follows: burnt umber, thalo blue, Hooker's green deep, yellow ochre, cadmium red medium, cerulean blue and titanium white.

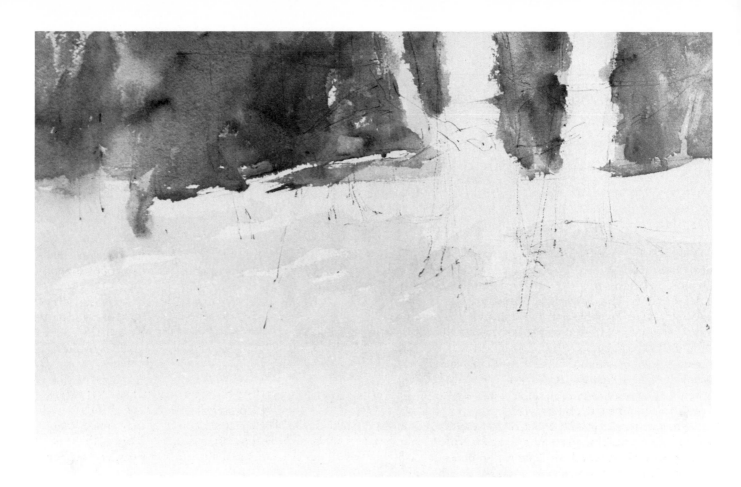

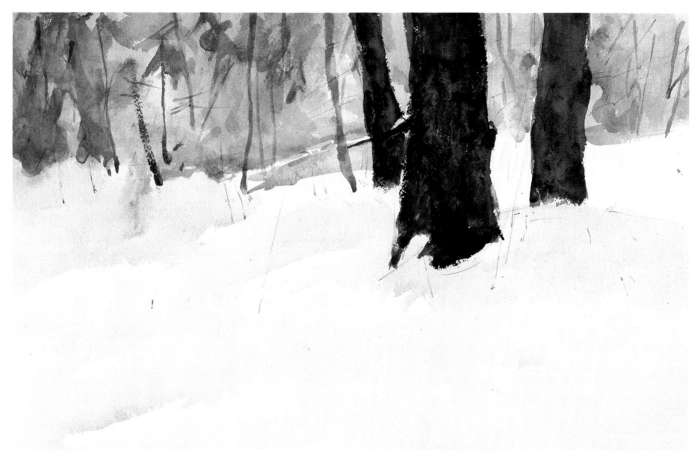

Stage 1: The subject was lightly sketched with pencil directly onto the watercolor paper. Then I prepared a color mixture of pale green by combining cerulean blue, yellow ochre, a bit of burnt umber to gray the color, and a little white to give it a soft hazy appearance.

This color was boldly brushed over the upper area with my #9 brush. I varied the mixture as I proceeded, adding a little of one color and then another for some variety, according to the impression I received as I looked at the scene.

While this area was still wet, I mixed a large puddle of very pale blue-gray using some cerulean blue and a little of the mixture used for the background. I also added a little more white since I wanted the color quite flat and uniform in tone. However the color is still quite transparent for it contains a good amount of water.

Using my large flat brush I began at the far left, starting in the wet color of the background so the two areas would blend together. I didn't want the edges between snow and trees to be too distinct in the deeper woods.

I then laid in the rest of the shadow area of the snow, leaving the white of the paper for the brighter area in the clearing beyond the larger pines. Almost accidently I left a few patches of white within the pale washes on the left. I decided to leave them to suggest some light filtering down through the trees.

Stage 2: I then went back into the distant woods on the left with some darker green tones to indicate the next closer group of trees.

The approach I used to create an impression of deep woods is to begin with the larger masses of tone for the most distant area, then add successively darker tones and more distinct shapes as I come forward. The colors of the tree trunks will also get warmer as they come forward.

The three large trees on the right cover most of the background in this area, so I'm not concerned with progressive changes from background to foreground. For this reason I now establish the big trees with very dark colors. This is a mixture of umber, green and dark blue.

I plan to show some texture on the trunks of these trees. If I were using watercolor, I would build up the texture by working from light tones to dark within the tree trunks. But with acrylics I can go back over these dark areas with lighter colors because the undertones will be waterproof when it dries. This is the only area where I have decided to use the special qualities of the acrylic paints.

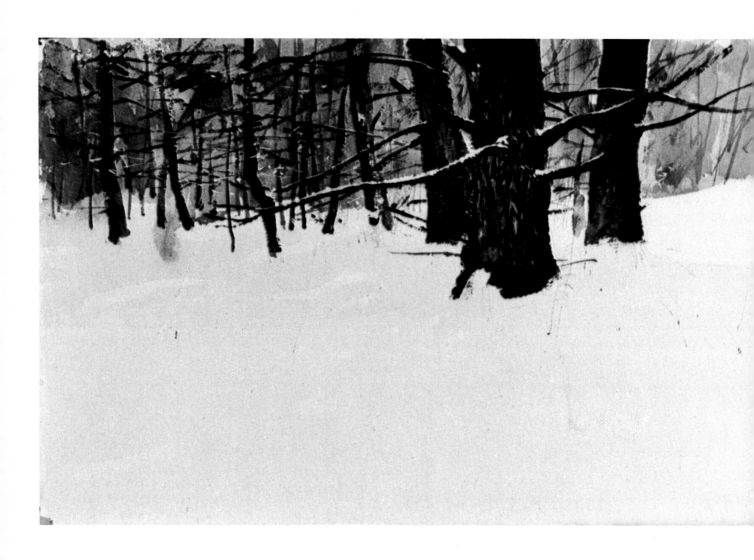

Stage 3: In this third stage I have added some darker tree trunks on the left.

I began putting in the horizontal branches. Here it is important to recognize the character of the pine trees. The branches grow almost horizontally on this species of tree. In another part of the forest, where there is a different type of tree, the branches would take on a completely different appearance.

Another characteristic of these branches is that we are looking at dead ones for the most part. The live growth is high up in the trees where the sun can reach it.

At this point I started putting in some of the texture on the larger tree trunk. I mixed opaque color of a pale violet using white, cerulean blue and cadmium red. The strokes are of a vertical nature, indicating the structure of the bark. These tones are quite subtle, for I do not want to destroy the dark image of the tree.

Next, I prepared a mixture containing mostly white plus a bit of cerulean blue. This color is quite opaque, for I've added only enough water to make the paint flow. I now used this to put in some snow on the branches.

Stage 4: I once again worked on the trunk of the large tree to strengthen the bark texture a bit more. I used some yellow tones on top of the cooler ones, lightly scrubbing it over the rough surface of the paper. A few touches of red were also added.

Darker trees were also added to the left side of the painting and some darker green washes applied over the upper parts of this section.

At this point I felt the need for a darker tone in the snow on the far left and around the base of the two trees on the right. With the acrylics I was able to paint right into the tree trunks without fear of lifting the darker color.

I worked some more on the three larger trees, refining the details.

Finally, I put in the twigs and branches sticking out of the snow and added the thin sapling between the two pines on the right.

You might note in the final painting my reason for working on a rough paper. In some areas there is a ragged edge on the dark strokes, where the paint did not go down into the depressions. I feel that this contributes to the character of the rough trees. Anticipating the character of the forms in your painting can help you determine whether to use a smooth or rough paper for your subject.

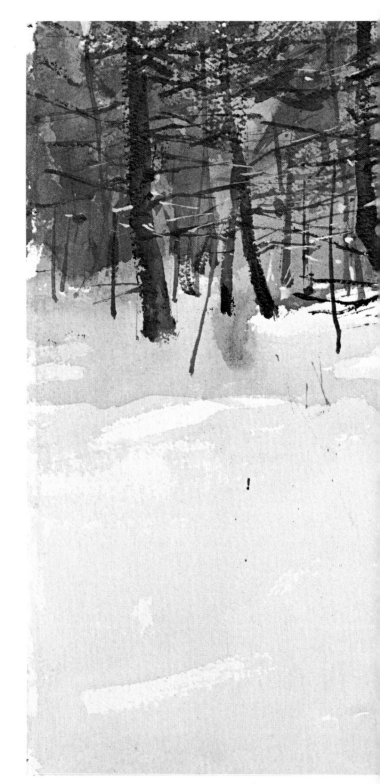

The Pines. Acrylic on illustration board, 13½ × 21½ inches.

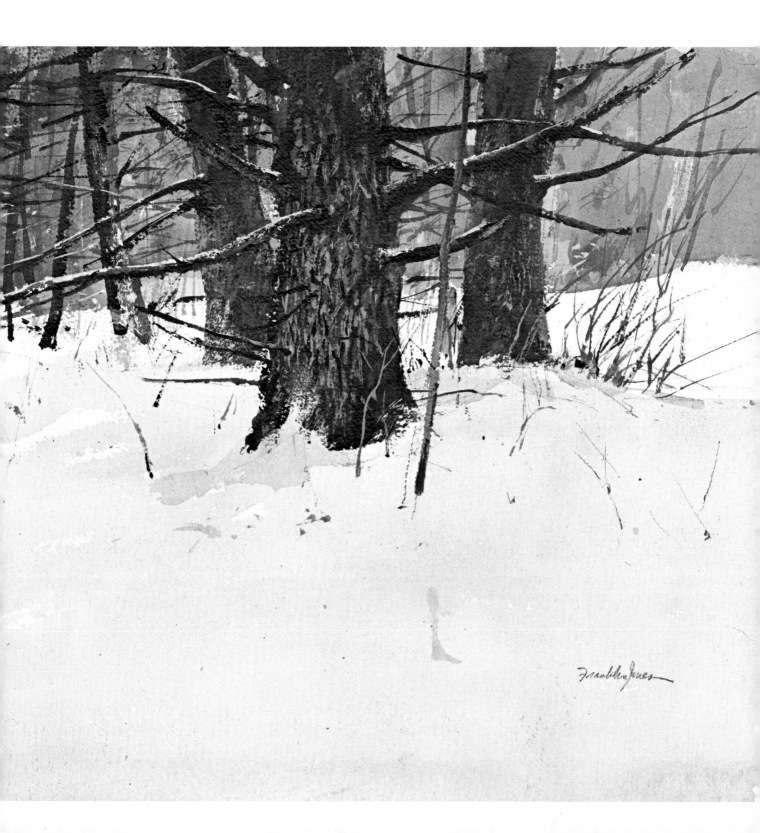

Stones, rocks, ledges, boulders — whatever the term, they exist in profusion on this earth and in an endless variety of sizes, shapes, color and textures. In their largest form they exist as mountains. In small pieces they fill the shallow stream beds that come down from the mountains and are scattered over the open fields, jutting out of the land or resting upon it. At a larger scale they form ledges, canyons and the shores of our oceans. We use the material for stone walls, gravestones, cobblestone and building block. In all of these forms they are frequently an element of landscape painting.

As we set out to paint them, whatever their size, a basic consideration is the overall structure, whether round, angular or a combination of both. The first step is to establish the large planes either by showing the separation of sunlight and shadow areas or, when there is no direct sunlight, by showing value and color changes observed in the subject.

Next, within the larger planes one looks for the smaller value changes in the contour of the surface. On each of these stages the roundness or angular quality is produced by controlling the edges between planes. On a rounded form the edges between light and shadow or the different planes are blended so that they appear relatively indistinct. On an angular surface the edges are quite distinct.

I would say that the most common weakness when painting rocks, especially in the smaller sizes, is making them appear too soft and round like cotton balls. This results from having them too sphere-like and a uniform blending of all the edges where the form turns. Correcting this is usually a matter of observing the shapes in nature more carefully.

Repetition is a necessary ingredient of teaching, and so I again stress the importance of learning to see what you see. Especially observe the shapes of shadows carefully, both those on the object itself and those cast by the object. Shadow construction is frequently neglected in students' work.

Rocks or boulders rising out of the ground, or even resting on the surface, should appear to be doing so and not floating on the surface. Rocks are heavy and we want to express that in the painting. One way to achieve this feeling of them resting solidly on the ground is to make the edge between the rock and the ground relatively indistinct in contrast to the edge along the contour of the upper part of the rock.

The degree of detail one needs to develop in any rock forms depends on the artist's intention and manner of working — the distance at which they are observed, and their importance in the overall painting. At times a few brush strokes are all that are necessary to create a sufficient impression.

When painting a wall composed of many small stones set one upon the other without mortar, as in the fieldstone walls that line a farmer's property, it is usually best to begin by laying in the entire group as a mass rather than putting in individual pieces. After the top and side planes of the wall have been established you can then show the separation between stones. Even then it isn't usually desirable to clearly define each piece, especially if the surface is in shadow.

The texture of the stone's surface is usually implied rather than carefully copied from nature. In all three mediums a granular texture can be achieved by dragging the brush lightly over the underpainting so that pigment is deposited only on the high spots of the painting surface. Watercolorists frequently use spatter work to indicate a rough texture. This is done by flipping the brush at a painting or tapping the brush against an object causing the paint to spatter onto the work.

When the texture of the rock is smooth and the construction quite angular, the artist may find the painting knife an appropriate tool for achieving this effect. The paint is applied by spreading it with the knife as though putting butter on bread. This is especially effective with thick opaque paint as in oil painting, but can also be done in watercolor painting.

With respect to color for rocks, again as I mentioned in the discussion of trees, these forms are not just brown or a neutral gray. There are many subtle color variations, depending on the composition of the material itself as well as by influences of the surroundings reflected onto the surface.

Choosing subjects for a demonstration of stone for my book was difficult because there are so many possibilities to explore. As I think about the land in my own vicinity I can hardly envision a setting without them. Up in the woods behind the house there is a gorge filled with massive moss-covered boulders tumbled one upon another and forming a myriad of small caves and tunnels occupied by timid porcupine, their spoor scattered about at their entrances. Sunlight tries to penetrate the canopy of overhead trees and filters down upon delicate ferns and vines.

Just down the road a piece, the Housatonic river fights its way among flat-topped boulders that thrust themselves above the surface. They remind me of feeding hippos in their bulky rounded shapes and leathery color.

The Explorer. Acrylic on Masonite, 9 × 12 inches.

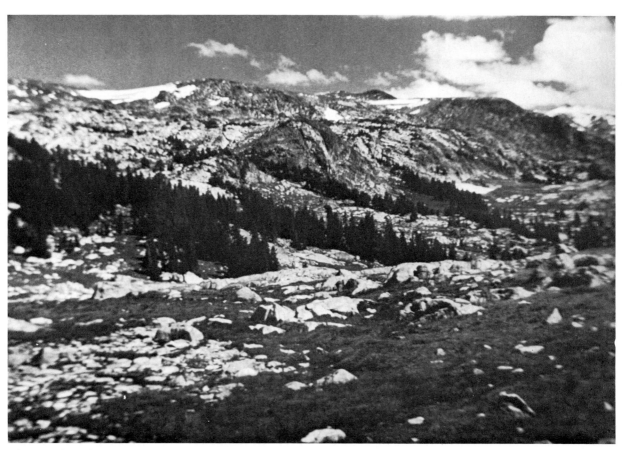

Photograph of the scene

Demonstration 5
A Mountain

An oil painting

As I drove along the higher elevations of the Rockies on my way into Yellowstone from Montana I thrilled to the vast mosaic of scattered rock, groves of evergreen that climbed the slopes and the carpets of green grass. In the clear mountain air even the most distant forms stood out with such clarity that it seemed I could reach out and touch them. I could sense the distance only because of diminishing sizes.

If one seeks quiet and solitude while enjoying the pleasure of painting, I can think of no better place than areas like this. Add to this the fact that it was a delightfully pleasant day in mid-September and you have a painter's paradise.

Hard put to visualize which area of the landscape would provide the most satisfactory composition, I made several small 4 × 5 inch pencil compositions. I did not attempt to include all the small rocks within the scene, selecting those that seemed most descriptive of the land or best fit my design. After all, my painting was only to be 16 × 20 inches and I felt it would be too cluttered if it contained too many small pieces.

A comparison of the photograph of the scene and my painting will show that I was able to be more selective than the camera, expanding or condensing the different areas of the scene to include or exclude them as I felt the need.

In the final painting you will see that I have simplified the details of the distant mountains in order to strengthen the feeling of distance in the painting. The canvas is a two dimensional surface, yet I want to convey the dimension of depth.

For this painting I worked on a canvas panel. The colors used were burnt umber, thalo blue, alizarin crimson, cadmium orange, cadmium yellow light, cerulean blue and titanium white.

I worked with flat bristle brushes in sizes #3, 4, 7 and 8, plus a #4 round bristle.

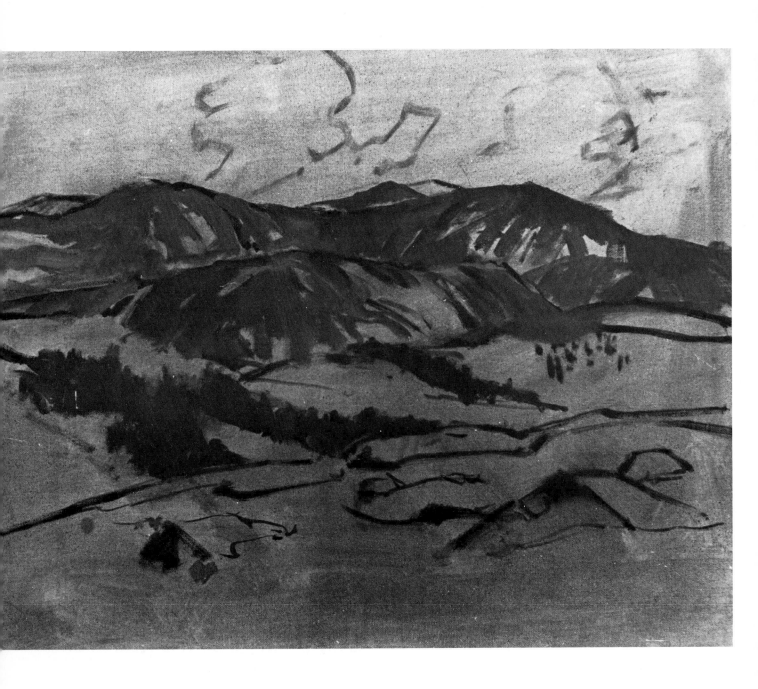

Stage 1: I decided to tone my canvas with a fairly intense, dark red color. The reason: since I envisioned using predominately blues, greens and grays in the color scheme, I felt it would give a little more vitality to the painting if a contrasting hue showed through in any areas where I didn't completely hide the undertone. I don't intentionally leave areas of the canvas showing, but they occur when the paint is laid down very directly, with a minimum of brushing the colors together.

I then sketched the main shapes of the scene using burnt umber. The evergreens, being the darkest forms, were brushed in with the same color, just to establish their general value.

Then, using blue-gray mixtures of cerulean blue, burnt umber and alizarin crimson, I put in an undertone for the distant mountains. Note that the direction of the brush strokes helps establish a feeling of the form in the mountains. Even though this is only an undertone for later painting I like to sense the three-dimensional qualities as I proceed.

I have varied the tones slightly, darkening those areas of the mountains that will be darker in the final version. I planned to keep the mountains in soft shadows from the passing clouds, so I can show stronger value contrasts between distant areas and the sunlit foreground.

Stage 2: I then moved on to the grass areas in the distance and foreground, using varying mixtures of green. The basic color is a combination of thalo blue, yellow ochre and a little cadmium red. For the more distant areas I added some cerulean blue and a bit of white.

There is no attempt to define or refine the rock shapes as I quickly lay in these colors. At this stage I'm just feeling my way, using color and value to provide an undertone for the land. However I did put in the dark shadow tones of the rocks.

Note that I am considering only the largest of the rocks. Any smaller ones will be put in at a later stage.

One could cover all of the foreground with the grass tones including the rocks, then re-establish the rocks later. As is my personal habit, I prefer to keep the general image of the scene always there in front of me, so I leave the rock shapes in.

I next moved to the sky area, for I want to establish some paint here before I begin developing the upper edges of the mountains. It is generally preferable to paint a nearer form over the one behind it, for it produces a better sense of overlapping. As with most rules this is a generalization and you should not be bound to it unless it is the practical approach.

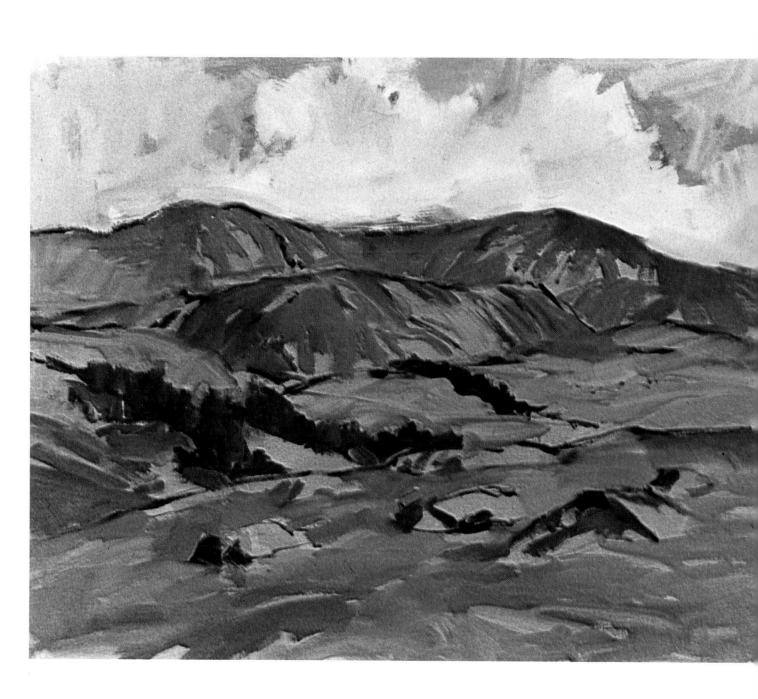

Stage 3: I refined the shapes of the clouds a bit more, establishing the soft edges between clouds and sky. Any sharper edges will be defined in later stage.

Next, I moved to the distant mountains, working from the darker tones to the lighter ones, using progressively thicker paint. Again I have simplified the shapes observed in the scene.

The mountain on the right shows less distinct value changes within the form, since this area is to be in the shadow from an overhead cloud. I've also made the shadow side of the central mountain darker than it appeared in nature. These two darker areas add variety to the overall value pattern.

I put in a few light tones on the foreground rocks to help me judge the values for the distant areas. As I've indicated, I want the foreground generally lighter than the distance.

At this point I have decided the sky should be changed since I don't care for the large masses of the clouds. They tend to be too repetitious of the big masses in the other areas.

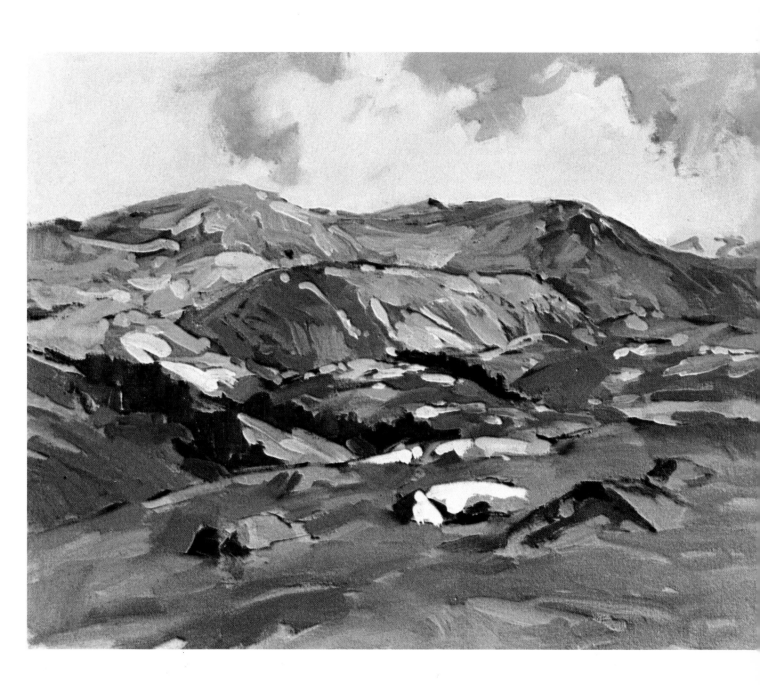

Stage 4: In this final stage I restated the sky using a fairly strong blue for much of the area to suggest the clarity of the atmosphere in this mountainous region. The clouds were made smaller and quite indistinct, so they wouldn't attract too much attention. The brush strokes were dragged quite firmly through the wet underpainting to produce a blending of the color and a softness of edges.

Next, the foreground was developed, beginning with a refinement of the grass. I did not try to smooth out the patches of color, for I wanted a certain roughness implied in the land. Each brush stroke was boldly laid down, but by keeping the value differences quite subtle there is still a consistency of tone throughout the green areas.

Next, I refined the shapes of the evergreens, putting in some of the pointed tops to indicate the character of these trees.

I adjusted the shadow tones of the foreground rocks and then, with fairly thick colors, the light areas were established. The various angles of the brush strokes help define the form of these rocks. As with other areas I built up the shapes with progressively lighter tones, varying the colors according to my impressions of those in the scene. These colors lean toward both warm and cool pale grays and were produced from mixtures of white, cerulean blue, cadmium red and yellow ochre.

Even though the foreground rocks were painted very boldly with small chunks of paint, I kept the separation of light and shadow planes constantly in mind, so that there is a consistency in the lighting and a feeling of solidity in the forms.

I was not so fussy with the smaller stones scattered about since they are not large enough to warrant such detail.

The final accents of small patches of snow in the distance brings the painting to completion.

Rocky Mountain. Oil, 16 × 20 inches.

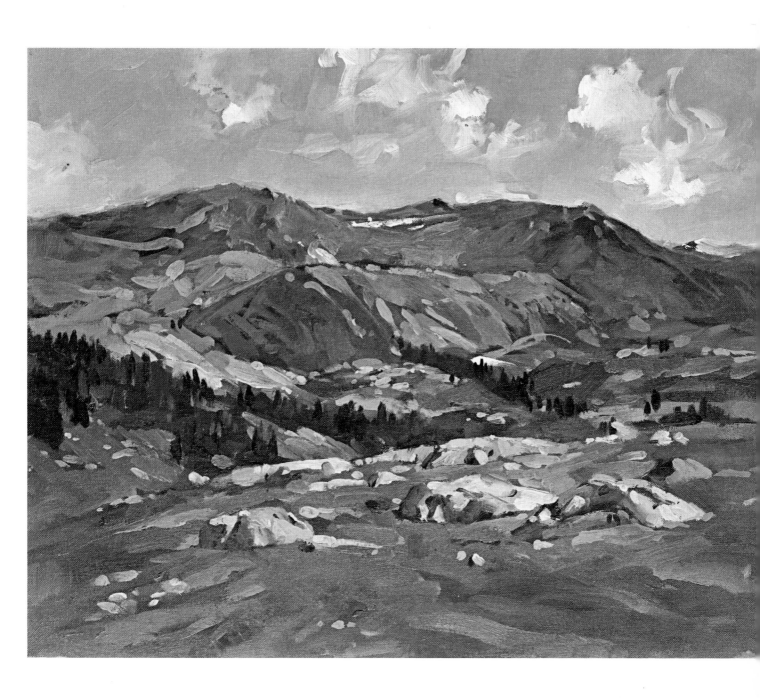

Preliminary study for The Stairway.

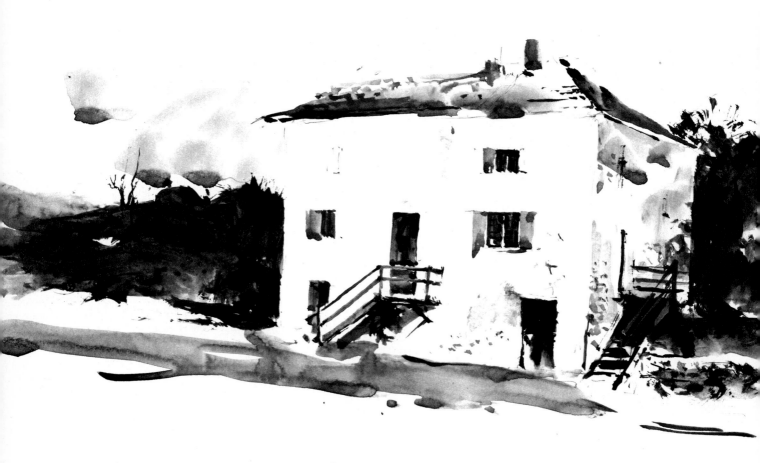

Demonstration 6
Stone Building

An acrylic painting

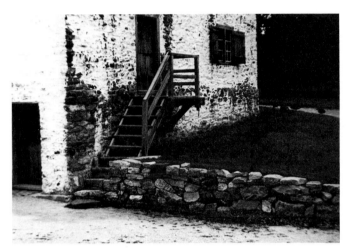

Photograph of the scene

I find a special fascination in old buildings, both in their design and in the character they acquire from years of exposure to the elements. This particular stone house is such an example, with its worn, white-washed surface streaked from rain and freckled with the underlying stone.

My specific interest in the scene was the simplicity of the building as a shape, and the varied textures in it and the surroundings. As a demonstration for this book it offered the chance to incorporate the stone retaining wall along the edge of the lawn.

I had first made the small study of the total building shown on the facing page. But subsequent sketches, moving in closer to show only a portion of the building seemed to give me what I was after. I could put more emphasis on the textural details and I liked the movement in the design. One of these composition studies is shown at the top of the page.

Even though this subject is largely architectural, there is a strong thrust created by the dark shape of the grass area. It moves like an arrow toward the left, while the white mass of the building provides a counter thrust. The diagonal shape of the stairway seems to nicely complement the strong horizontal and vertical lines.

The painting was done on a Masonite panel previously coated with acrylic gesso.

My colors were burnt umber, Hooker's green deep, manganese blue, yellow ochre, cadmium orange, cadmium red medium and titanium white.

My brushes consisted of a watercolor #5 and #9 round sable, a #0, #3 and #5 bamboo, a ¾ inch flat oxhair. I also used a #5 flat bristle oil brush.

Stage 1: The main lines of the scene were drawn directly onto the panel using a 2-H pencil.

Then I prepared a mixture of burnt umber, Hooker's green and yellow ochre. Using the flat ox-hair brush this color was applied to the grass area. The flat side of the brush, with the tip pointing toward the top of the panel, was pressed against the surface in a repeated operation until the entire area was covered. This produced a tone with an indication of vertical lines within the color.

Next, using the #5 bamboo brush and a mixture of Hooker's green and burnt umber, the mass of trees in the upper right corner was put in. The brush was pressed firmly to the panel and pushed upward to produce the jagged edge along the top.

The doorway at the top of the steps was put in with burnt umber and cadmium orange.

Next came the doorway on the left, using umber and green.

The tone for the stone wall was a mixture of cerulean blue and burnt umber. I scrubbed this quickly onto the surface, so that bubbles formed in the wash. As they dried they formed dark spots.

With a similar mixture the vertical wall on the left was given a slight tone, but the color was brushed on without the agitation.

Stage 2: I put in the darks representing the under area of the stairway, a blue-green tone for the window at the right end of the building, a similar color over the piece of sky above the trees and over the wall on the far left.

At this point I went back over the grass in a manner similar to the first stage, but with darker green color. Some individual vertical strokes were put in this same area. My intention here is to slowly build up the grass texture in a series of transparent and opaque layers.

Similarly, I now began to build up the stone wall. For this second layer of color I used burnt umber applied in a thin layer, pushing and shoving the color around to provide tonal variation and texture.

A light ochre wash was added to the foreground.

The next step, which doesn't show in the photograph because I was working white on white, was to go over the wall of the building with relatively thick paint in random patches. This white was dragged over the surface using my flat bristle brush. In the example at the top of the page, I've applied the same type of stroke to a darker background so you may see the effect.

The purpose of this white paint is to build up a slightly rough surface.

Over this entire wall I applied a very pale wash of gray, mixed from cerulean blue and umber. As the wash dried it settled in the minute depressions of the rough textured surface, giving a feeling of the white-washed wall. Even though this tone is so pale as to be hardly evident in the photograph, it does provide a textural quality evident in the actual painting.

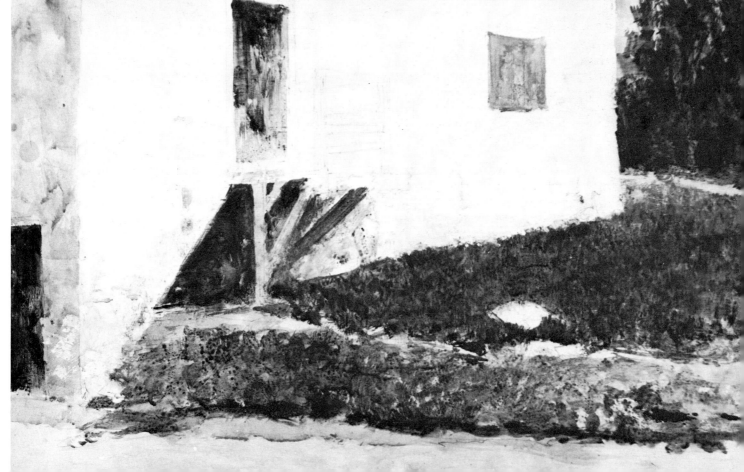

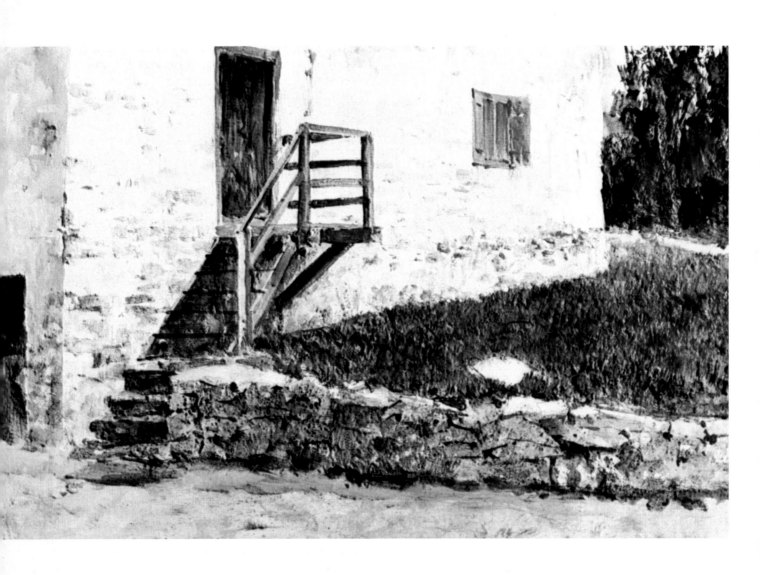

Stage 3: Now I started to refine some of the areas. I began by putting in the porch railings and the lower steps.

Next, I put in some of the individual stones showing through the white-washed surface of the building. These were applied with thin color, using the side of the brush, so that the color was lightly patted on, thus providing an indistinct edge to the strokes.

Then, using my small bamboo brush and dark umber color, the thin lines were put in to indicate the separations between the rocks in the stone wall. Note that all of the stones have not been carefully or clearly separated. This wall is in shadow and there should be some loss of detail — some sense of mystery within the shadows.

I then darkened the ground just under the wall to indicate the grass growing along the edge of the gravel.

I next went over the two doorways to darken them a bit and at the same time indicating some of their character. The lower doorway has the upper part of the Dutch door open, so this interior is very dark.

Some refining of the window separates the shutters from the glass area.

The versatile character of acrylic paint, used in this manner of transparent washes and opaque pigment, allows for constant adjustment of any area. Therefore I can be rather bold in putting down a piece of color until the final stage. Establishing a value for the subject is the essential thing at this point. If the value is right, or nearly so, you will be able to use it as control for any amount of refinement you might want to add later, as you'll see in the next stage.

The Stairway. Acrylic on Masonite, 19 × 29 inches.

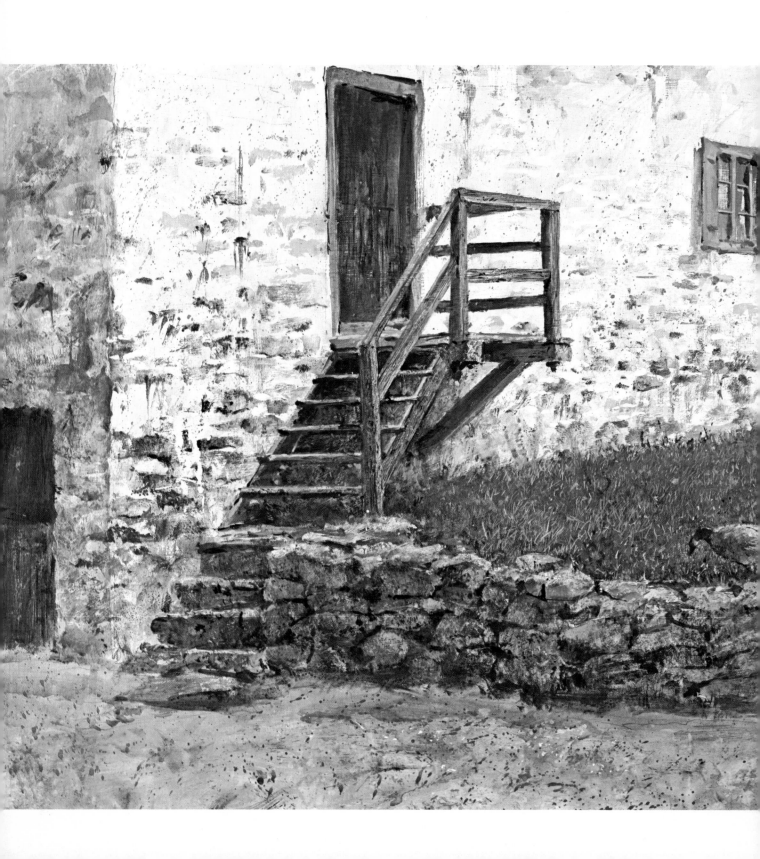

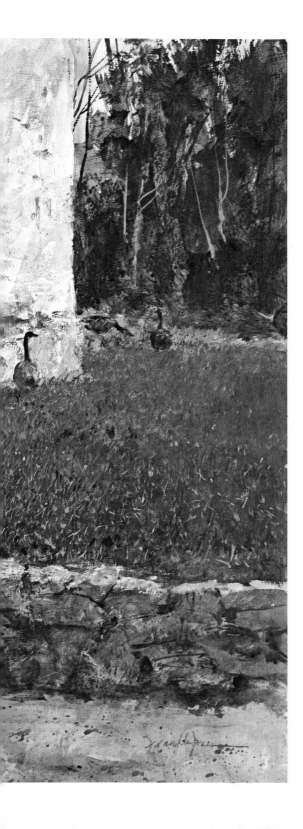

Stage 4: Here in this final stage you can see how subtle, minute brush strokes were added within the stone wall to achieve a sense of form. I used opaque color to model some of the stones, then went over them with transparent layers of umber or blue to lower the value back to the tones established in Stage 3.

To soften the appearance of the grass and achieve a sense of realism in its texture, I went back over the entire area using minute brush strokes of a semi-opaque color. This was a mixture of yellow ochre, Hooker's green and a touch of white.

I again went back over the wall of the building, adding more stones and some of the streaks evident on the weathered surface. Another pale wash of color was added in some areas. Finally, I used a little spatterwork to further the rough weathered texture.

More detail was added to the railings of the porch.

The geese were put in for added interest in the scene. However, I purposely kept them low in value in keeping with their surroundings so they wouldn't be overly important. I've tried to make the stairway and door the focal point of the painting.

Some texture by means of spatterwork was used in the immediate foreground.

The painting is finished — or at least for the moment. Perhaps later on I'll get the urge to refine it still further.

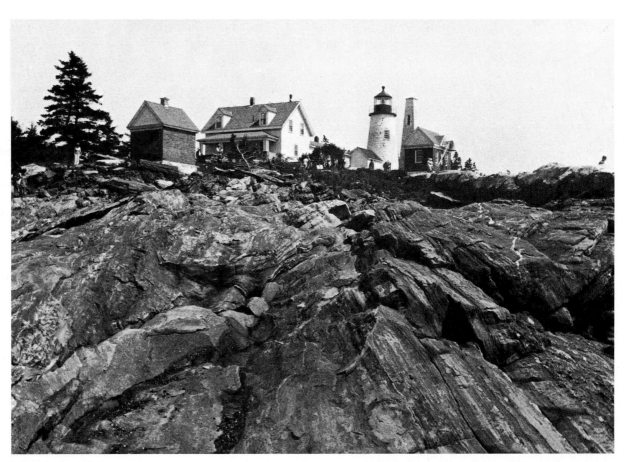

Photograph of the scene

Demonstration 7
Rocky Coast
An acrylic painting

The sea itself could keep me busy painting for a lifetime. But turn your back to it along the coast of Maine and you'll find another wealth of inspiration. Fishing villages, marshlands, wooded hills and rocky shores all tantalize the artist.

On a summer afternoon I was down below the lighthouse at Pemaquid Point painting a watercolor of the sea (demonstration 10 in chapter 4) and when it was finished I turned around to paint the scene shown here. Massive rocks, bared by the sea and the wind, rose high above the water's edge. The coast guard station, keeping its ever watchful eye on the Atlantic, glistened bright in the sun.

I painted the scene pretty much as it looked, except for dropping the little brick building on the left a bit further down the slope and giving more of an angle to the top of the land on the right. I moved the brick building because when I was up at the top it was apparent that it is actually down the hill some distance below the other buildings. From the lower view this was not apparent.

The greater slope to the land on the right helps achieve a feeling that the land drops away toward the sea. It actually does, but not within the view I had selected to paint.

This acrylic painting was done on a 16 × 20 canvas. My colors were burnt umber, thalo blue, cadmium orange, Hooker's green, yellow ochre, cadmium red medium, cerulean blue and titanium white.

I used mostly bristle brushes for this painting, in sizes #4, 6, 8, and 11: also a #3 round watercolor brush, a flat ¾ inch watercolor brush and a painting knife.

This painting, unlike the preceding acrylic works in the book, was done mostly in the manner used with oil paints. That is, the colors were lightened by the addition of white and the paint applied fairly thickly. At certain stages, however, thin transparent glazes were applied over the underpainting. Such a procedure can be used with oils, but it requires letting the underpainting dry before adding the glazes. This would require waiting several days. With acrylics, the thick underpainting only required about fifteen or twenty minutes to dry.

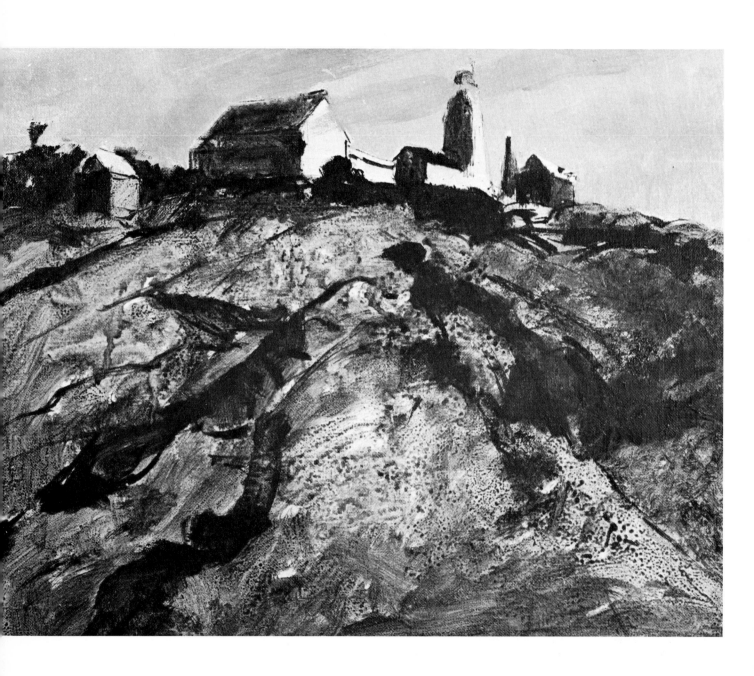

90

Stage 1: The outlines of the buildings were sketched onto the white canvas with my #3 watercolor brush using burnt umber. Then, with a #4 bristle brush and burnt umber, I put in the darkest tones that represent the major crevices and dark areas of the rocks as well as the growth along the top of the hill.

This color dried within a few minutes and I then applied a thin wash of umber over the entire rock area and for the darker areas of the buildings, using my flat watercolor brush.

Next, I prepared a pale blue opaque color by combining cerulean blue, cadmium orange and quite a bit of white. Using a #8 bristle brush I painted the sky, varying the tones a bit and applying the paint with diagonal strokes to suggest the presence of hazy clouds sweeping across the sky.

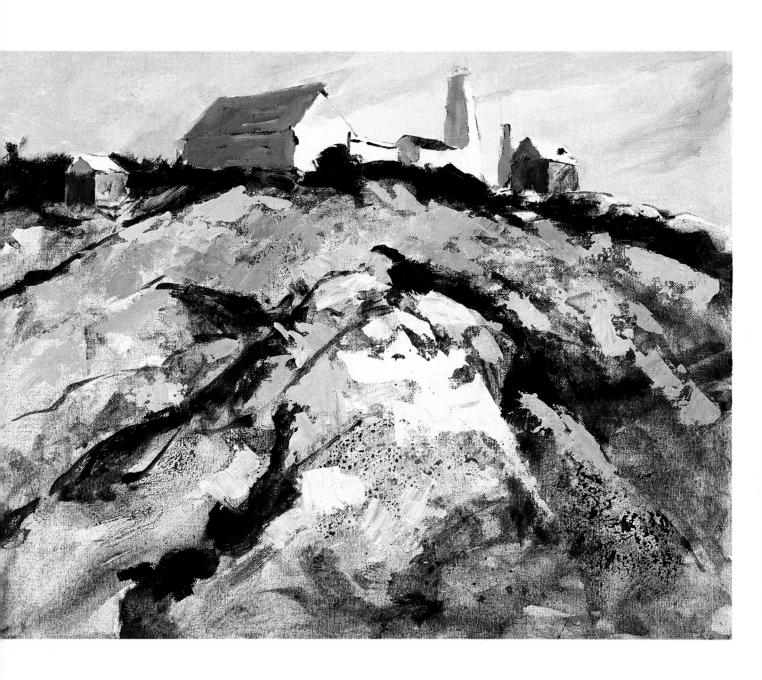

Stage 2: Using my smaller bristle brushes I put in the shadows of the buildings with varied tones of blue mixed from thalo blue, orange and white. Then I used a mixture of Hooker's green and yellow ochre for the grass and trees.

For the two red buildings (those on either end of the group) I used a mixture of cadmium red and some of the green already mixed on my palette.

Next, using mixtures of thalo blue and cadmium red, I went over the darker areas of the rocks.

Then, using the painting knife, I went over much of the surface of the rocks with thick applications of very light mixtures of gray and white. The gray was made from white, cerulean blue and umber. This paint was applied in the manner of spreading butter on bread. In some areas I would scrape the paint quite thin, allowing the texture of the canvas to show through. The direction of the strokes varied as I tried to feel out the planes of the rocks. As I worked toward the center of the painting I used pure white paint.

I used the knife because it produces a strong angular quality to the strokes that is characteristic of the rocks themselves. My use of the lightest tones in the center area was to give a feeling of roundness to the total area, suggesting that the middle section is coming toward us, thus pushing the buildings into the distance.

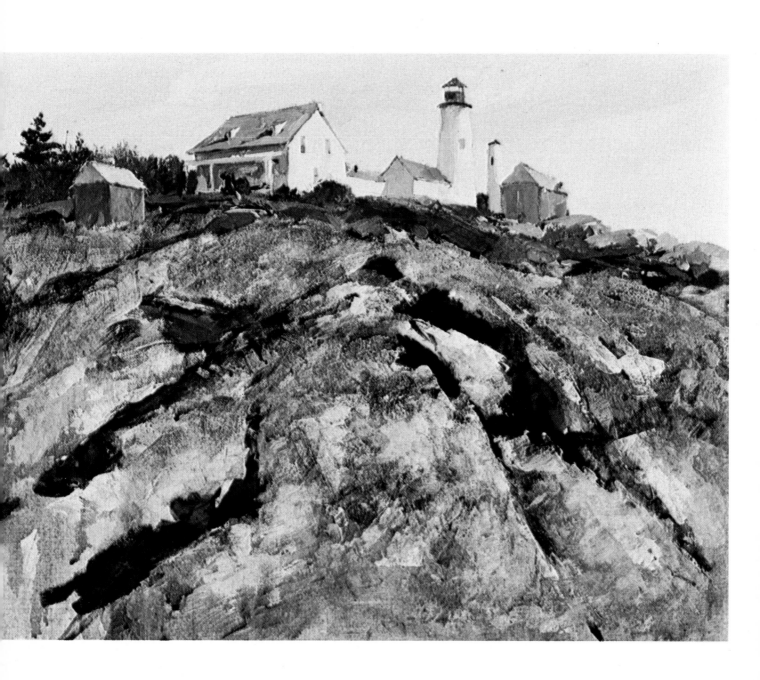

Stage 3: At this stage I primarily concentrated on refining the distant areas, working on just about every object. Note that the shadow on the lighthouse is blue and quite light, for it is influenced by the open sky overhead. On the other hand, the color of the shadow on the building just to the left is quite yellow, for it is affected by the sunlight bouncing off the adjacent building.

I have kept the windows in the building and lighthouse light in value in order to emphasize the bright sunlit shapes. The lightest areas of the buildings, which up to this point were bare canvas, have been painted with fairly thick white pigment that has been warmed with a touch of yellow ochre.

Then, a thin transparent glaze of burnt umber, slightly grayed with a bit of thalo blue, was brushed over the entire rock area, using the flat watercolor brush again. The color was scrubbed on vigorously, for any speckling or streaks would add to the rough textural effect I was after.

You will note that this color settled more into areas where the underpaint was not built up so thickly and smooth. So the center area of the painting still appeared light in tone.

Stage 4: Except for some minor adjustments in the buildings, the background was complete and I next concentrated on the rocks.

First, I went back into the darker areas, lightening them a bit and introducing small brush work in the two diagonal dark passages on the left. These were not actually crevices, but depressions in which many dark colored clam shells had been deposited over a period of time by high water.

Then, once again, I went back into the lighter areas with light opaque paint to model the form of the rocks. This was applied with both knife and bristle brush. Much of the underpainting was still allowed to show through. I also worked over some of the slightly darker areas on the left and right sides in the same way.

In a repetition of the previous stage I went over the rocks with more transparent washes, first with very pale umber and then, when dry, with a glaze of yellow ochre.

The final step was to add dark linear strokes with umber or thalo blue to indicate the fine cracks, crevices and other irregularities on the surface. This was done with the #3 watercolor brush. At the last moment I gave the brush one good rap against my closed fist to spatter some dark color in the lower right area. The painting was complete.

Pemaquid Point. Acrylic on canvas, 16 × 20 inches.

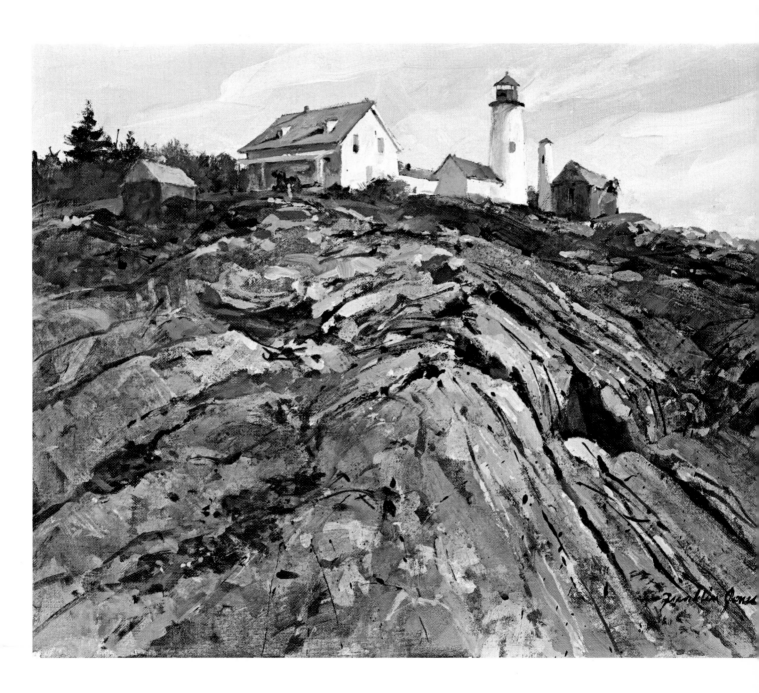

Photograph of the scene

Demonstration 8
Stone Wall
A watercolor painting

One need not look far for a stone wall in my part of the country. They separate fields past and present, and are even found wandering aimlessly deep in the woods where once, long ago, there were open farmlands. Most walls are made of rounded stones cleared from the fields and piled one upon another without mortar. Others are cut-stone neatly fitted and set with or without mortar.

I have been particularly impressed with the many carefully laid walls that are found in western Rhode Island. A portion of such work is shown in the study below.

For my demonstration painting I chose an old wall located in Dorset, Vermont, representative of many that one might find in a landscape setting. I came upon it in the afternoon in early spring. A few patches of snow still lingered in the protection of the evergreens.

This painting was done on a 140 lb. rough watercolor paper in a watercolor block. A block is a quantity of sheets glued together around all four edges. When the painting is dry it is removed from the block by running a dull blade under the four edges. This particular paper was 18 × 24 inches.

I used the following colors: burnt umber, light red (a Winsor & Newton color), Hooker's green, yellow ochre, alizarin crimson and manganese blue.

My brushes were a #9 round sable, #5 round sable and a ¾ inch flat sabeline.

A sabeline or oxhair brush, while not as good as genuine sable, is much less expensive. I generally select either of these for my larger flat brushes.

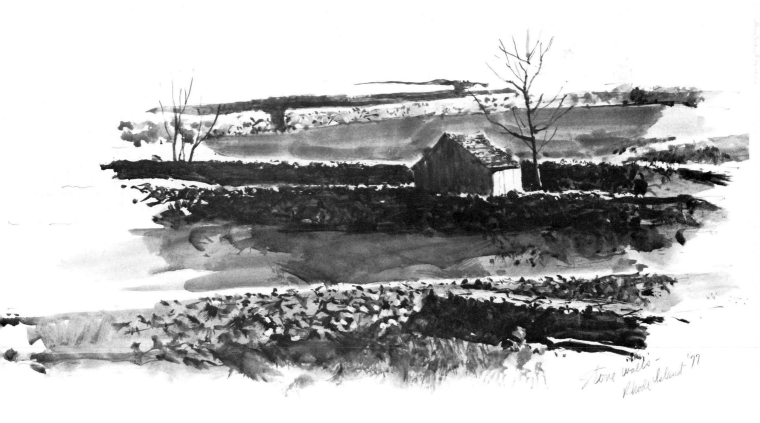

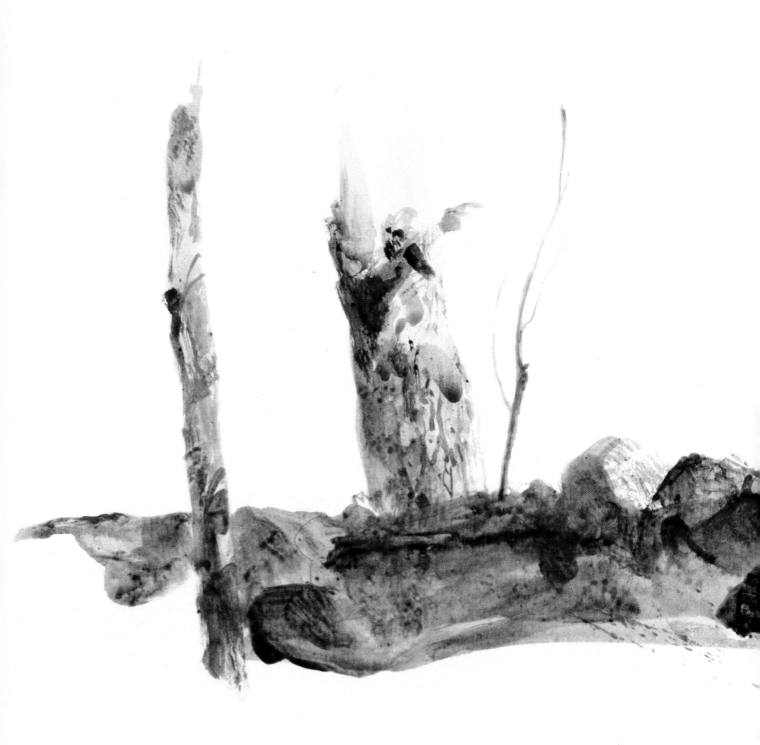

Stage 1: After lightly sketching the scene on the watercolor paper I prepared a mixture of manganese blue and light red. Using a #9 round brush I applied the color over the entire area of the wall that was to be in shadow. You will note that I did not apply a flat wash, but varied the tones as I worked from left to right by adding more pigment to my mixture or by diluting the color on the brush with additonal water.

When the shadow areas were complete I used a pale wash to put in a tone on some of the lightstruck areas.

Next, using a mixture of yellow ochre plus a bit of burnt umber, I painted in the field beyond the wall, leaving the tree trunk untouched.

Stage 2: I put in a general color for the background trees, using a mixture of burn umber and Hooker's green. I started at the right, letting the color touch the wet sky to produce a soft edge in this area. In the center area I left some white paper to represent the sunlit branches of the two apple trees. On reaching the left side I continued down into the tree trunk with the same color.

Next, while the background was still wet, I went back into some areas with a dark green to produce light and dark variations within the foliage.

I next went back into the wall to indicate some darker passages, varying the color a bit as I worked. The colors used in the mixtures were thalo blue, burnt umber and light red. In this bold watercolor approach I'm after a general impression of the stones rather than an exact copy of what is there.

Next came the undertone for the immediate foreground, using a mixture of umber, ochre and light red.

The large tree trunk was now dry and I went back over it with a mixture of umber and Hooker's green.

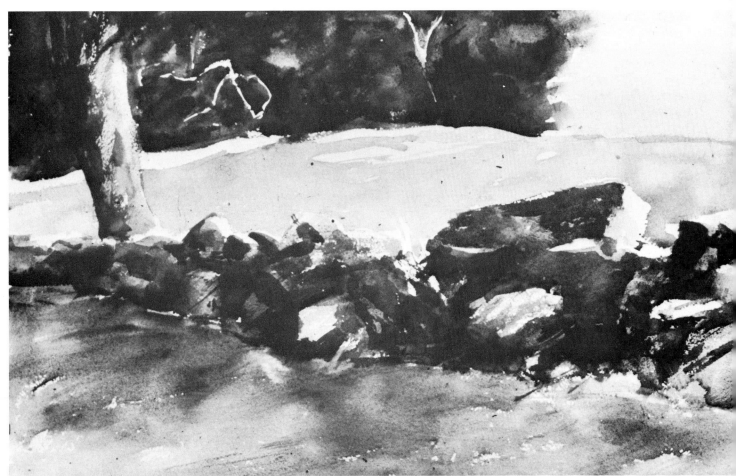

Stage 3: Once more I went back into the wall with darker washes as I continued to work toward the deepest shadows. In some areas the mixtures contained thalo blue and umber. In other areas I used light red or yellow ochre washes.

Then I moved down to the foreground using a variety of brush strokes to indicate the rough character of the ground, using my #9 round brush and umber.

Next came the distant hill on the right. For this I used a mixture of manganese blue and alizarin crimson. When the wash had partially dried I scraped the back of my thumbnail firmly through it to lift out some color and to establish the light fence posts. (If this is done while the area is too wet the color may run back into the scraped area making it darker than the wash itself.)

At this point I felt the need to add another wash over the left side of the field in order to give a bit of form to the ground and to strengthen the contrast between it and the patches of snow.

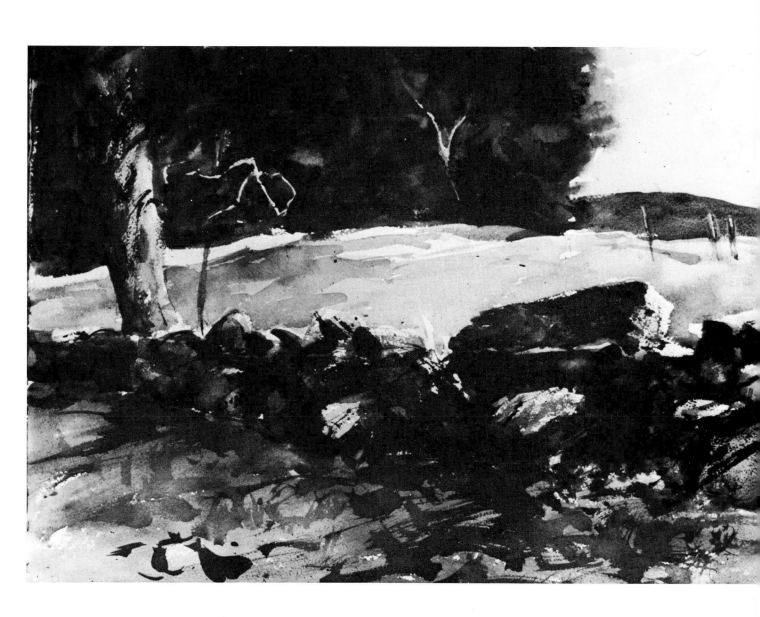

Stage 4: Now came the darkest accents in the stone wall and any refinements of the character of the stones. I used a bit of dry-brush to indicate the granite-like texture on a couple of those that were raked by sunlight.

Further work was done in the shadow area along the base of the wall and then I added some spatter-work, both light and dark, to the foreground.

Next, I put in the darks of the distant apple trees and the thin sapling next to the large tree.

The final step was to scratch some thin strokes with the point of a knife. This was done to indicate some light struck branches in front of the wall, a bit of grass on the right and some very thin branches on the apple trees.

As I studied the completed painting within the framework of a mat it seemed to be more effective with less of the dark background trees, so I cut a few inches off the top.

The Boundary. Watercolor, 15 × 22 inches.

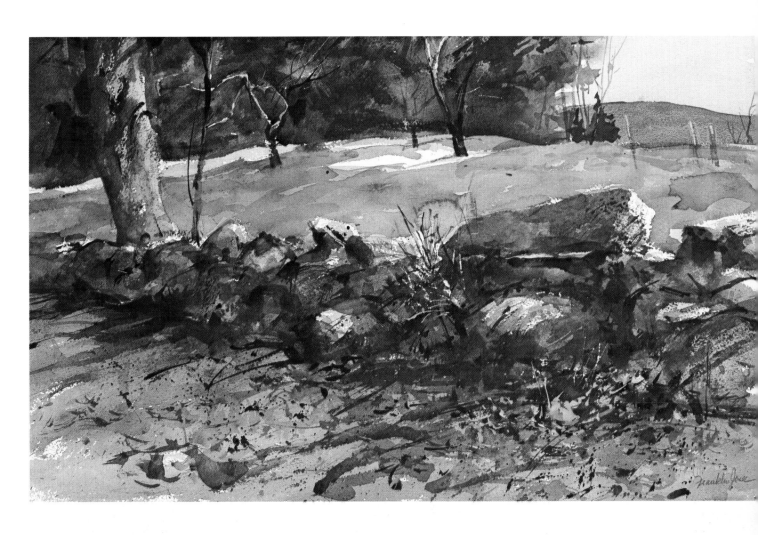

Watching The Sea. Watercolor study, 9 × 12 inches.

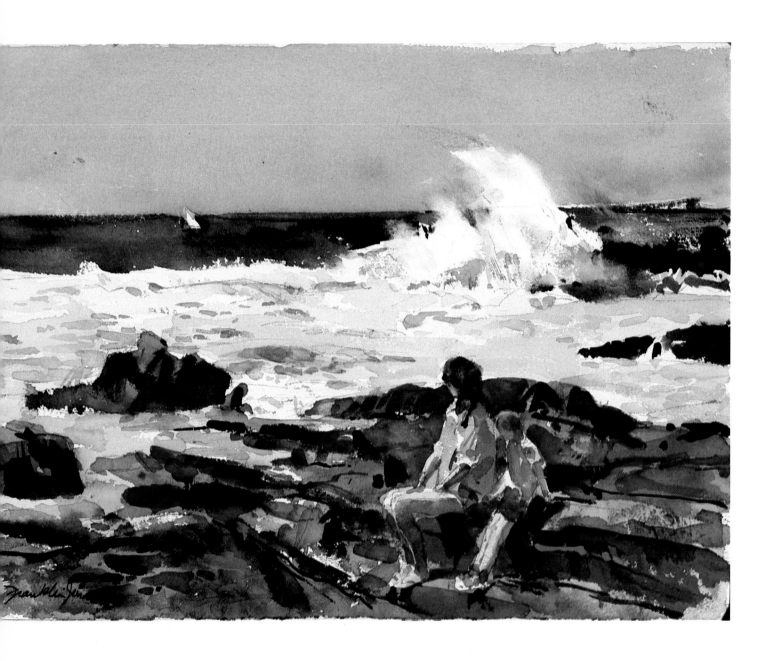

Chapter IV
Painting Water

Water, as anyone knows who has tried to paint it, is an elusive subject. Like a child, it doesn't hold still long enough to be painted. Therefore one must fix the images in the mind and paint the impression that has just passed. At one moment it is a passive flat expanse of color broken only by reflections cast upon it. In another moment a breeze ripples the surface, and the reflections are gone. At yet another time the surface is churned into waves that move in an endless chain and dash against the shore. Yet behind all these changes there are some basic principles of painting to help the artist record the realistic impressions that he sees.

Once more we go back to the ingredients that bring a landscape to life on the canvas. We see shapes, values and color. Transposing the more important of these images to your painting surface through careful observation will result in a representation of nature.

We might begin by visualizing a perfectly flat piece of water, void of any surroundings other than the sky. Simply painting a flat tone across the canvas would represent this subject, though we might not recognize it as water at this stage. Next, we would need to add some other passages that characterize water. Add a strip of land and a tree to the far side of the water, paint an exact reflection of these elements upside down on the surface and we begin to see an impression of water. Its surface is a mirror of the surroundings.

In most instances it is more convincing as a representation of water if we see some indication of movement in the reflections. Unlike a sheet of ice, the surface is easily disturbed by the wind or flowing currents. By blurring and distorting the shapes of the reflections we can produce an impression of this movement. Now we have a better visual impression of water.

Using these same principles we can paint the waves on a windswept body of water. As I've indicated, the water reflects its surroundings — light tones for the sky or other light objects nearby — darker tones for the landscape or any other dark objects. As the

water rises to form a wave, the angle of the surface is changed and as it changes it reflects another part of its surroundings. One area of the wave may reflect the light sky toward us while another area reflects some dark object. By observing the shape of the wave and these tonal differences you can produce an impression of a wave.

The waters of a brook, tumbling over barely submerged stones and sweeping around objects, represent another approach for the painter. Again the surface reflects its surroundings where it is smooth and mirror like. As the water drops over a stone or log it takes on some of the color of those objects, or we see the color of the water itself if it's muddy or contains other impurities. The fall of the water can be expressed by the vertical direction of the brush strokes used. The movement of the water around objects is produced by subtle value and color changes as well as the sweep of the brush strokes. Ripples on the surface and other areas where the glint of the sun appears will be very light in value. . .tiny diamonds sparkling among the darker tones.

The very color of the water itself will have an effect of the visual appearance of the surface. Muddy or silty waters will have a general ochre or yellow tone, whereas crystal clear waters will show the influence of the bottom coloration. This latter is particularly evident in the shallow streams that flow over the light colored stone and gravel of the western terrain.

While very deep water may appear quite dark in relation to the surroundings in one situation, it may appear very light in another, depending on the extent of reflections on the surface.

A fairly distinct separation of values between the brook or stream and the surrounding landscape helps establish a clear impression of water and land. Regardless of the amount of small detail you include in each area, the distinction should be evident. A help in analyzing the tonal differences between the water and land is to study the scene through half-closed eyes. This procedure is useful in that it tends to reduce the minor value changes in the landscape and allows you to see the big value patterns.

The practice of squinting at a subject for this purpose becomes almost a trademark of the artist. It can become embarrassing at times, for I find myself squinting at my friends as I see a possibility of making an interesting design out of their shapes and postures.

In fact, I had one elderly lady student who used this procedure so much that her doctor thought she must need glasses. She had to explain that she was just looking at him as a subject for a painting. But I'm drifting away from the theme of painting water.

When painting a seascape, keep in mind that designing an interesting composition is just as important as in depicting a landscape. Even if you are painting only the water itself you should design the waves, the open sea, and the waters between the waves, as carefully as possible. If your painting contains rocks, think about their placement and balance in relation to the water. Remember, you can move the rocks or vary the sizes in order to achieve the best arrangement.

Nothing is more breathtaking than when the water is absolutely smooth and we see a mirror reflection of the landscape. Turn the scene upside down and it would be difficult to determine which is the actual scene and which the reflection. This is a frequent and exciting subject for many artists. However, as a painting I find this somewhat confusing to the viewer. Remember that you don't have real water in your painting — only an illusion. It is better to show some distinction in the reflection, either by introducing some indication of the surface being disturbed by a streak of rippled water cutting through the reflection or by making the reflection less distinct than what you observe.

Once again I will remind you that water is not one color. Blue is a symbol for water but in reality it will vary considerably, dependent on the conditions. It may appear quite gray, green, blue or any variation of these or other hues. This is a difficult subject, but an exciting one.

1. *A flat tone could represent water, but it is hard to recognize it as such.*

2. *By adding a reflection of the surroundings we produce an impression of water.*

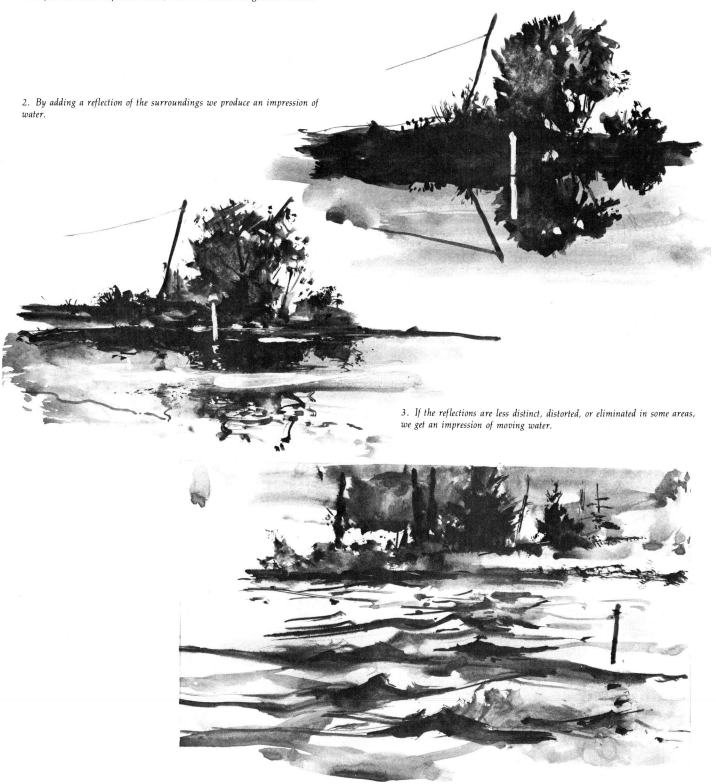

3. *If the reflections are less distinct, distorted, or eliminated in some areas, we get an impression of moving water.*

4. *Waves break up the surface of the water into rhythmic patterns of light and dark as they reflect different objects.*

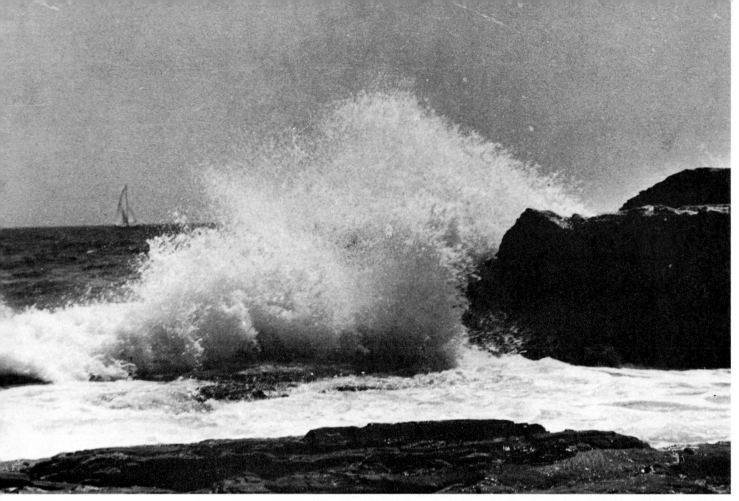

Photographs of the scene

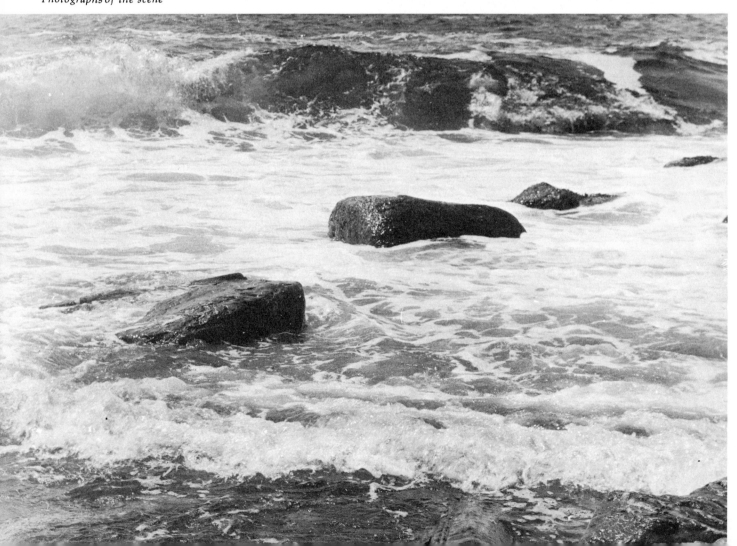

Demonstration 9
The Sea

An oil painting

We were camping along the coast of Maine on the day Hurricane Belle moved into New England and the following morning I climbed down the steep bluffs of Camden to watch the surging sea still pounding restlessly against the shore. Foaming white water moved among the rocks as though searching for a way to come ashore. The waves would roll slowly in and then suddenly explode into the air with a roar.

I find such a sea fascinating but frightening. I am reminded of those paintings by Winslow Homer in the Clark museum in Williamstown, Massachusetts, not far from my home. In these paintings Homer does not seek out the romantic beauty of the scene, but the power and drama of the ocean itself.

The ever-moving sea is difficult to paint, whatever its temperament, and one should study it frequently to understand the constantly changing forms. I personally feel that oil paint is most expressive for seascapes, for it seems to have a strength that suits the rugged qualities of this dynamic subject.

Unfortunately there is no photograph of the exact view I painted. However, I have shown some photos taken that day which illustrate the type of water that prevailed.

My painting was done on a 16" × 20" canvas panel.

The colors used were burnt umber, burnt sienna, alizarin crimson, cadmium orange, yellow ochre, cadmium yellow light, viridian, thalo blue, cerulean blue and titanium white.

Brushes were flat bristles #4, 6, 8 and 11; round bristle #4 and 6.

Stage 1: After making three or four pencil compositions, I sketched the major shapes onto the canvas using burnt umber. In this instance I did not tone the canvas because I wanted the white surface to represent the large areas of foaming water, thus enabling me to quickly see the overall effect of the scene as soon as the darks were laid in.

The darkest tones for the rocks were a varied mixture of umber, thalo blue, viridian and burnt sienna. All of the colors were quite muted and very dark.

Next, I put in the strip of distant water with a grayed blue color mixed from thalo blue, sienna and a bit of white. The paint applied was relatively thin for each of these steps.

Next, the sky was put in with grays, mixed from white, thalo blue, burnt sienna and alizarin crimson. To increase the stormy feeling I varied the values to suggest heavy clouds, rather than putting in the flat slate-gray of the actual scene. I wanted the sky to sort of repeat the same character as the bursting wave.

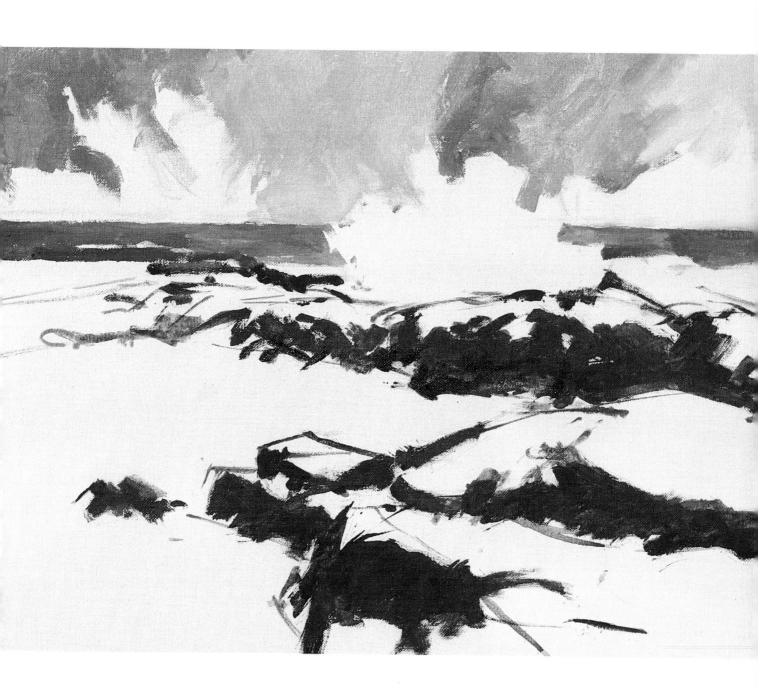

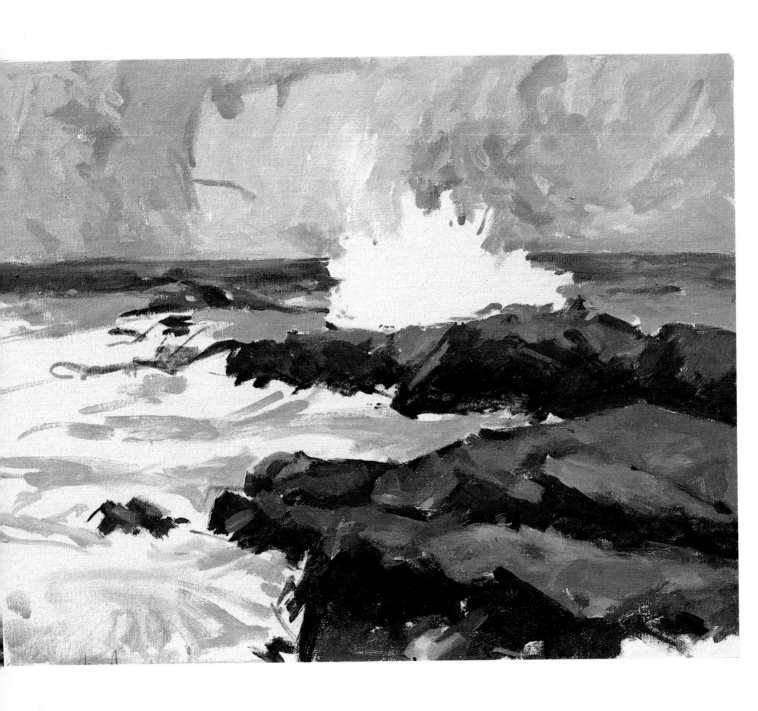

Stage 2: I then put in the upper planes of the rocks with the same colors used for the first stage, but with the addition of white in the mixtures. These areas were painted with my larger flat bristle brushes.

I went back into the sky again, pushing and pulling the paint around to give a stormy active feeling to the area. My round bristle brushes worked better for this than the square-tipped type. I didn't try to refine the sky completely at this point, just worked on it enough to give me something to think about.

I next worked on the distant water again, making minor adjustments in the brushwork and color and adding lighter, greener passages just below the darker band. These areas were also put in with round brushes using horizontal strokes with an undulating flow to them to suggest the rise and fall of the surface.

After that, I put in some pale gray-green color in the foreground water, as an undertone for the painting to follow. As I put in these strokes I kept studying the movement of the water and each stroke represents a kind of "shorthand" description of what I observed.

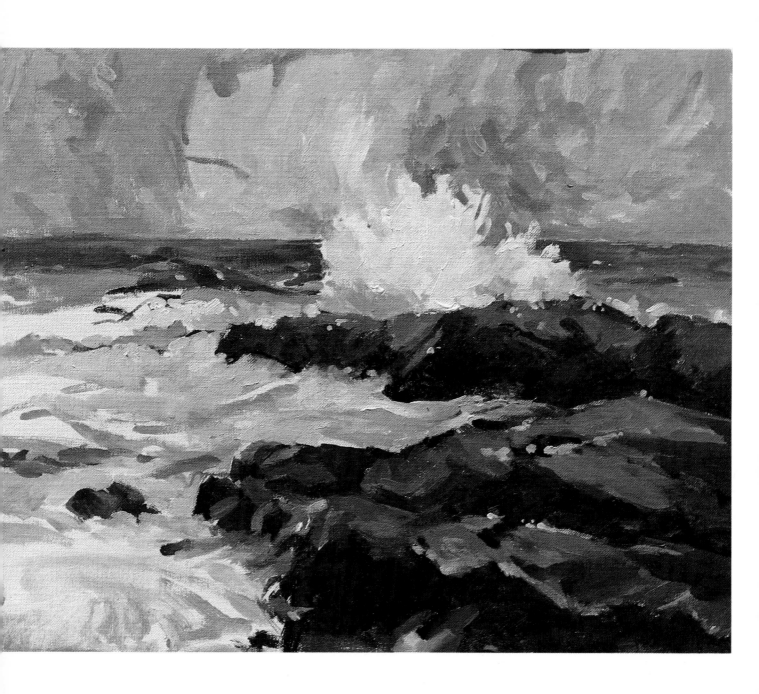

Stage 3: I now began to build up the wave as it moved in to burst against the distant rocks. As each wave rolled in I would grasp an image and put in a few strokes of paint. I repeated this type of observation for each section. Then I put in the slightly darker underside of the bursting foam with pale green and gray color. Over this I applied nearly white very thick paint for the lightest areas of the foam, dragging the paint over the background sky.

Then I moved on to the foreground water again, continuing to build up the motion with a series of long flowing strokes.

Along the bottom of the distant rocks I dragged the color into the dark wet paint to soften these edges and to give the impression of the sea lapping against the rock.

I try not to work too long in any one area, or I may carry the painting too far in relation to other areas. Remember, one thing effects another and if you spend a lot of time refining one thing you may find you have to redo it later when you adjust an adjacent form.

So. . . I moved back to the rocks again, adding a few lighter passages.

Stage 4: My next move illustrates the point I just made about not carrying one area too far. As I studied the painting it seemed the sky was overpowering the bursting foam because the various shapes were too distinct. The sky didn't seem to set back where it should. Had I completed the top of the light foam it would have meant taking it out again. . .not that this is difficult or time-consuming in this instance.

In any case, I went over the entire sky at this stage, softening the brush strokes and making the value contrasts more subtle. Then I restated the foam and carried it to completion.

I next worked on the near water, building up the surface with light thick pigment. In the very lightest areas I used pure white. I tried not to make the various tones and brush strokes too distinct in these areas since I hoped to convey a feeling of a moving, ever-changing surface.

The final step was to complete the rocks by adding the lightest, warmest values and putting in dark accents to indicate the crevices and varied planes. Except for a few highlights, the overall value of the rocks is darker than any of the surrounding water. Thus each area of the painting has its own value, and the large patterns are easily distinguished. Compare the completed work with the small value plan on the first page of this demonstration.

After the Storm. Oil, 16 × 20 inches.

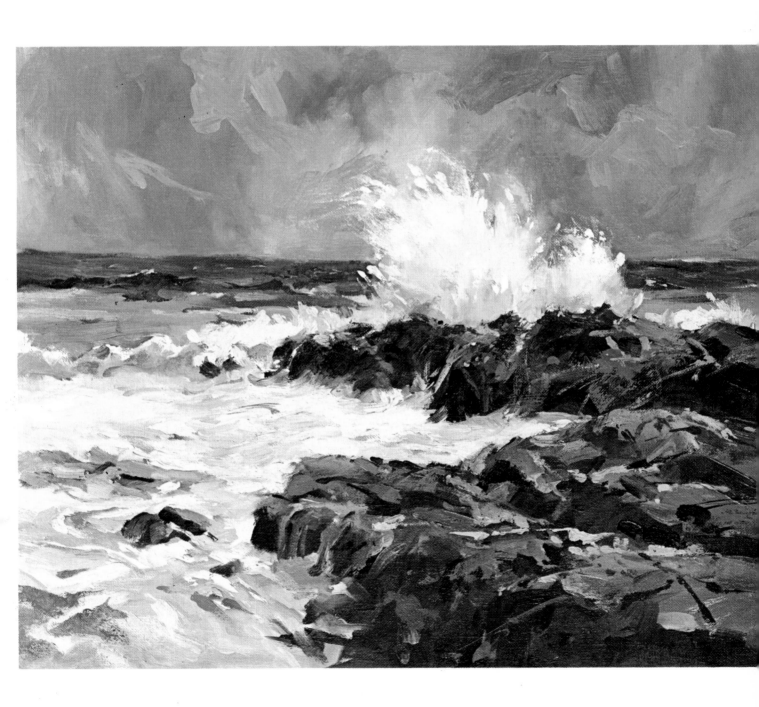

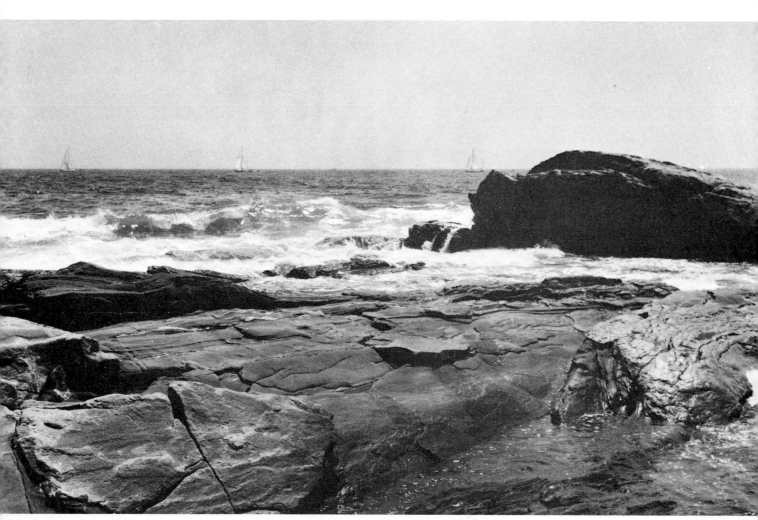

Photograph of the scene

Demonstration 10
The Sea
A watercolor painting

I have included this watercolor painting of the sea
so that you may compare the procedure with that
used for the oil painting in the preceding demonstra-
tion. The scene, as I previously mentioned, is a view
of the sea from the rocks at Pemaquid Point. The
day was fair with a brisk wind; the waves would
fling themselves against the rocks sending a spray of
foam into the air, then swirl around the rocks like
the rolling surface of a boiling pot.

In contrast to the oil painting procedure you will
see that I work from light to dark to build up areas
with watercolor. The white of the paper serves for
the lightest tones and no white paint was used in
any of the mixtures.

While I consider that an opaque medium provides
a feeling of strength to the powerful movement of
the sea, watercolor allows for a swift spontaneous
impression of the subject that can be equally exciting
to look at.

The painting was done on a 15 × 20 inch sheet of
300 lb. rough watercolor paper. With this heavy
paper there is very little buckling of the surface
while painting and for this reason I like to use it
when I want to work quickly without interruption.
With lighter weight papers I sometimes find it
necessary to let them dry before reaching the final
stage so the surface will flatten out.

My tube colors for this painting were burnt
umber, burnt sienna, manganese blue, thalo blue,
alizarin crimson and viridian.

I used a ¾ inch and a 1½ inch flat sabeline brush
and a #9 round sable.

124

Stage 1: The scene was sketched directly onto the paper very lightly with pencil. Then, with a mixture of burnt umber, manganese blue and alizarin crimson I laid in the undertone for the rock, using my #9 brush.

Next, I prepared a fairly good-sized puddle of color for the sky using manganese blue and burnt sienna.

Before applying this mixture I wet the paper with clear water in the area where the wave would break against the sky. Then, using my large flat brush, I boldly painted the sky except for the areas where the wave was breaking into it. The color blended into the previously wet area to produce a soft (indistinct) edge.

Note: *The pigment in manganese blue tends to separate into particles and settles into the depressions of the paper as the color dries. This produces the mottled effect that we see in this painting (you can observe this more clearly in the stages shown in color).*

Next, with a pale mixture of viridian (green) and yellow ochre I laid in a wash for the water this side of the rock.

126

Stage 2: Using the same color mixture of burnt umber, alizarin crimson and manganese blue as for the previous rock color, I next laid in the foreground rock mass. The color mixture was varied slightly in its proportions as I proceeded in order to produce warm and cool variations. I also added more pigment to the mixture for some areas to give light and dark variations.

Next, using this same color mixture, I went back over the distant rock to establish some darker planes. I let the previous wash dry first in order to have hard (distinct) edges between the lighter and darker areas.

At this point I felt the foreground rocks needed to be darker. So, without waiting for the area to completely dry, I went back over it with the same color mixture.

When the water was dry I went back over it with small, pale blue shapes to indicate the oval patches of darker water evident on the swirling surface. I also put in some blue tones to the left of the distant rock to indicate the darker planes of the wave in this area. The oval patches were put in with the pointed end of my round brush whereas the strokes to the left of the rock were done with the side of the brush which gave a more broken or rough edge to the shapes.

Stage 3: The dark distant sea was painted using a mixture of thalo blue and a bit of umber. While the paint was still wet I lifted out some of the color next to the breaking wave by blotting it with a paper tissue. This softened the edges and added a little more indication of the spraying foam.

Note that I painted around the small shape of the distant sail boat.

Next, I went back over the distant rock with still darker tones of umber and thalo blue. By letting each stage of the rocks dry before adding more tones, it achieved the rough angular character of the surface.

Now, with the same color, I added smaller strokes over the foreground rocks. Again, this helps show the changes in the angle of the surface. The strokes generally move in the same diagonal direction to show the cleavage of this type of rock. Their direction also helps lead the eye into the composition.

I also added some gray-blue strokes on the right just above the foreground rocks to show the incoming water tumbling onto the rock.

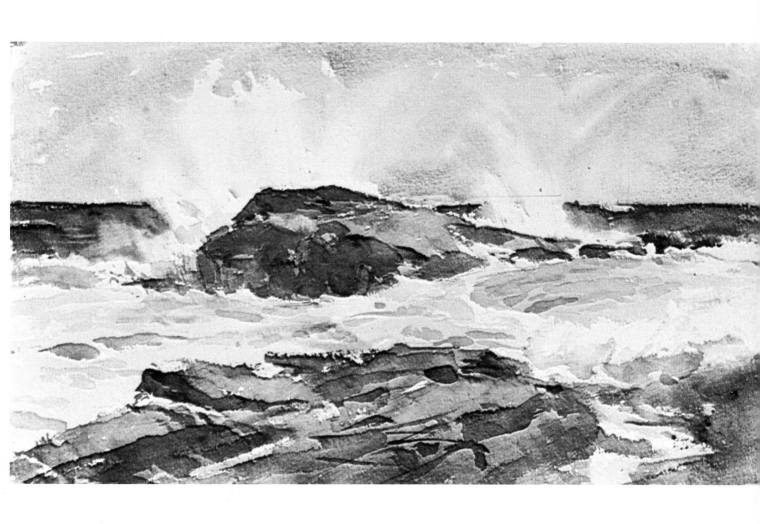

Clearing Storm, Pemaquid. Watercolor, 12½ x 22 inches.

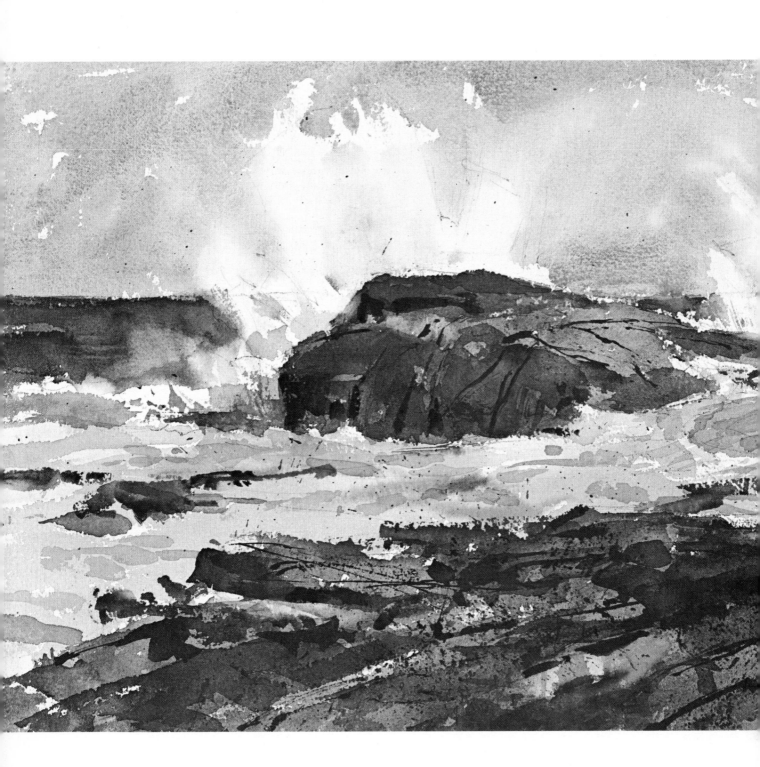

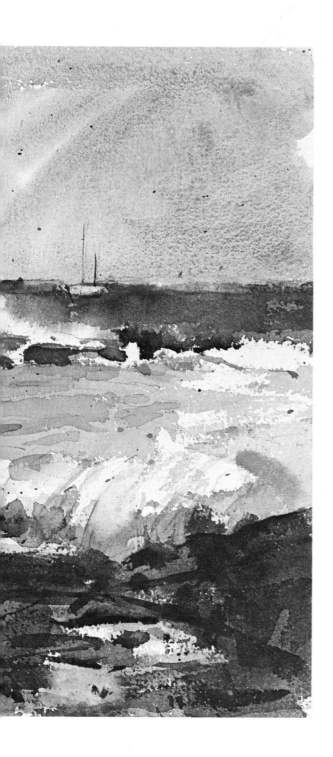

Stage 4: Some paintings may require considerable work during the final stage, but in this instance it was a very simple matter of adding dark accents to the rocks.

First, some dry-brush was applied to the foreground rock using the ¾ inch flat brush and a mixture of umber and thalo blue. Then some broad strokes were put in with the #9 round brush. Finally, very thin lines were added, using the very tip of the #9 brush. These lines indicate the cracks in the rock.

Thin lines were also added to the more distant rock to indicate the cracks, and the left side of this rock was darkened a bit. At this point I put in the smaller dark rocks on the left. The final touch was to put in the masts of the sail boat and the painting was complete.

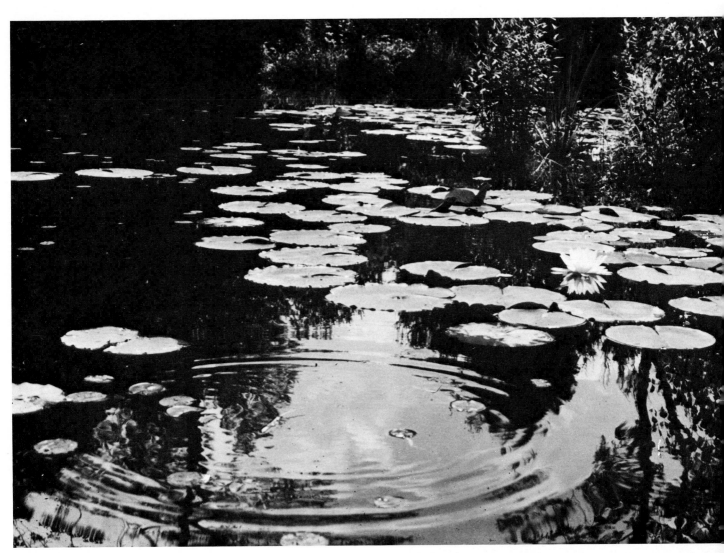

Photograph of the scene

Demonstration 11
The Pond

An oil painting

It is a quiet summer afternoon, and the only disturbance is an occasional ring of ripples as a goldfish rises to the surface and then lunges away with a swirl of its tail. The reflections sway from side to side in a slow dance. I find myself staring at the movement with the same fascination as when watching the flames in my fireplace.

For this painting of my neighbor's pond I chose to move in close to the water and concentrate on the pattern of reflections and lily pads.

In the darker reflections I can see into the water and catch a glimpse of the orange goldfish. The color of the slightly murky water is also evident in these areas. In the foreground the bright reflection of the sky hides the water beneath. The sunlit lily pads appear especially light against their dark surroundings.

My painting of this tranquil scene was done on a 16" × 20" canvas panel. My oil colors were burnt umber, burnt sienna, thalo blue, viridian, cadmium red medium, alizarin crimson, cadmium orange, yellow ochre, cadmium yellow pale, cerulean blue and titanium white.

I used both square-tipped and round bristle brushes.

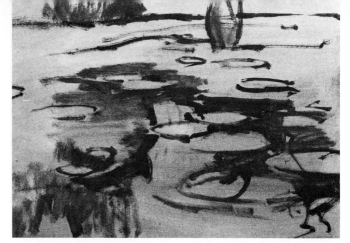

Step A

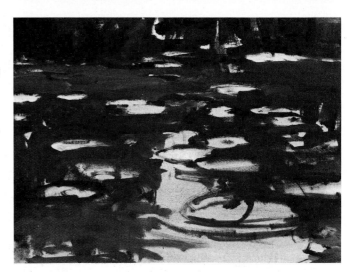

Stage 1 — Step A: In preparation for this painting I toned the canvas with a thin wash of burnt umber. Then the major shapes were drawn on the canvas with darker tones of the umber.

To help me visualize the arrangement, I scrubbed some dark umber tones on either side of the light passage down the center of the composition and around the lily pads.

Step B

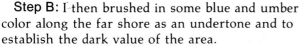

Step B: I then brushed in some blue and umber color along the far shore as an undertone and to establish the dark value of the area.

Next, I painted the water with varied tones of green mixed from thalo blue, burnt sienna and yellow ochre. The brush strokes were applied in a horizontal direction to help establish the flat surface of the water.

Step C: With the darkest tones of the major areas established, I began to adjust the color and value of the water, using thicker paint. For the smooth dark surface of the water, the various tones were blended together.

You can see that I have not tried to paint carefully around each lily pad. These shapes will be defined when I paint them over the water. I've only left enough indication of them to locate their positions.

I then put in some middle values along the shore, using a round bristle brush.

Next, I prepared a pale blue mixture of white, cerulean blue and a bit of the green mixture remaining on my palette. With a flat bristle brush I roughly laid in this color for the reflection of the sky in the lower center area. The color was allowed to blend into the darker greens to produce some soft edges where they come together.

At this point I put in the very light patch of paint just about in the center of the painting. This was just to get an idea of the value to use for the lightest lily pads.

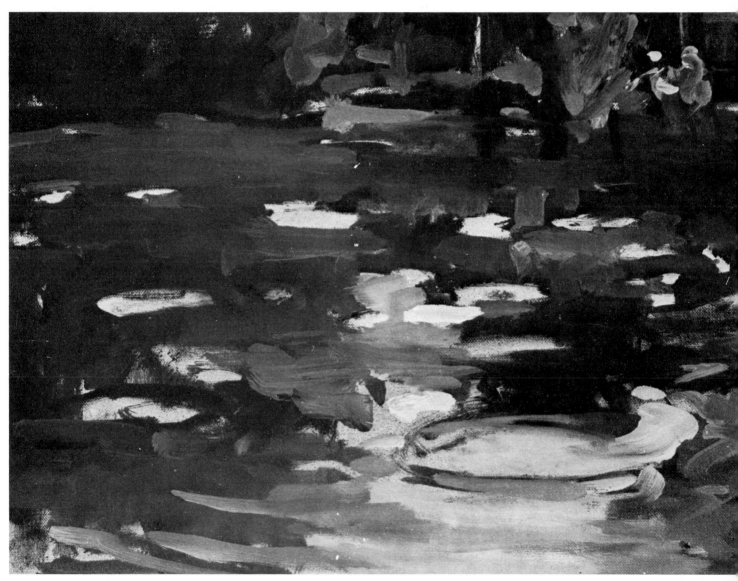

Step C

Stage 2: The previous stage was really building up a foundation of color and value to guide me, and now I was ready to adjust the total painting. I began by going over the darker areas of the water to further adjust the color, values and brush work.

I next worked on the light area in the center foreground, using quite thick applications of paint where I wanted to hide the underpainting — which was still wet. The strokes for the circling ripples were dragged firmly through the underpainting, so the two tones would blend together a bit in areas. This produced a variation of hard and soft edges on these strokes. They were put in with a round bristle brush.

The next step was to put in the lily pads. These were painted with a round brush using plenty of paint in order to cover the wet darker colors. The more distant pads were darkened slightly to help strengthen the feeling of depth in the scene.

Following this, I worked on the background shore. I purposely used vertical brush strokes in this area so that it would contrast with the horizontal feeling of the water. In this way the viewer can quickly identify the distinction between water and shore.

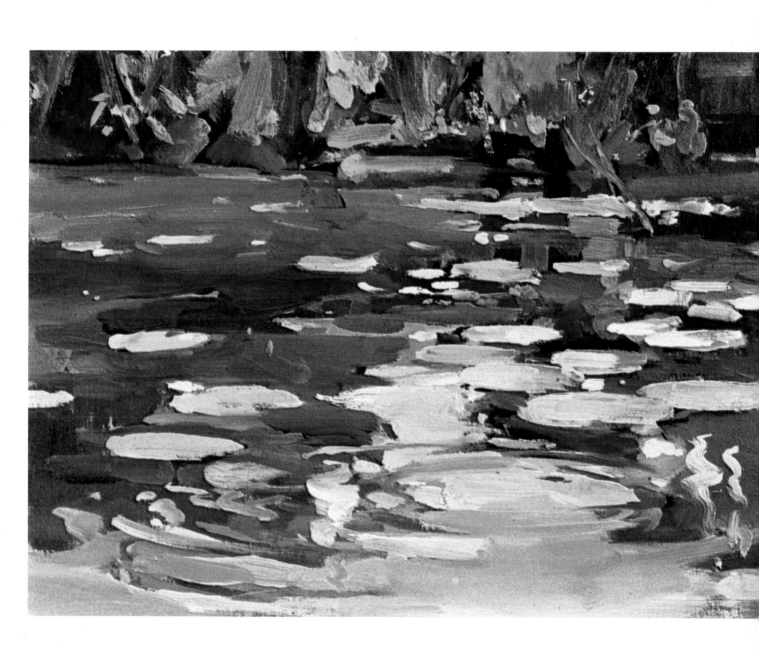

Stage 3: This final painting shows only minor adjustments from the previous stage. The most obvious one is the addition of the wriggling dark strokes in the foreground to indicate reflections of some tree trunks.

At this point I lowered the value of the big area of sky reflection just a bit. It seemed to be too bright and I wanted to give more attention to the lily pads. I also added a few dark curved strokes within the light area to indicate the presence of the ripples.

Remember earlier that I stated that as the surface of the water rises and falls in a wave (or ripple), it reflects different objects. So, in this instance, the ripples vary from light to dark in the light area; from dark to light in the darker reflections.

Finally, I added the smallest details. These include the tiny dark strokes on a few lily pads to indicate the cleft in the leaves, the pink water lilies and a vague indication of the goldfish beneath the surface. Even though the fish are of no consequence in themselves, they did inject a bit of warm color. I felt that this, along with some orange tones in the background, gave a little color variety to the overall cool scheme.

Pond Lillies. Oil, 16 × 20 inches.

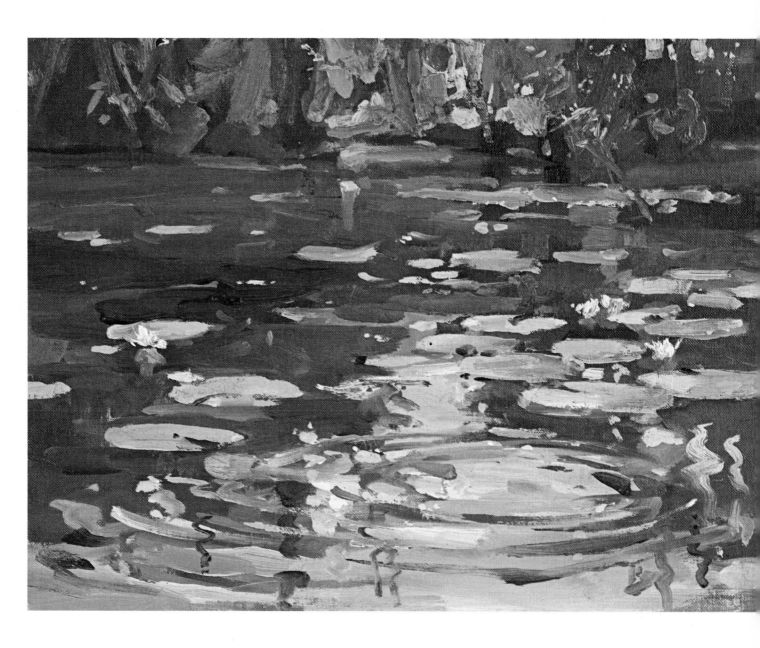

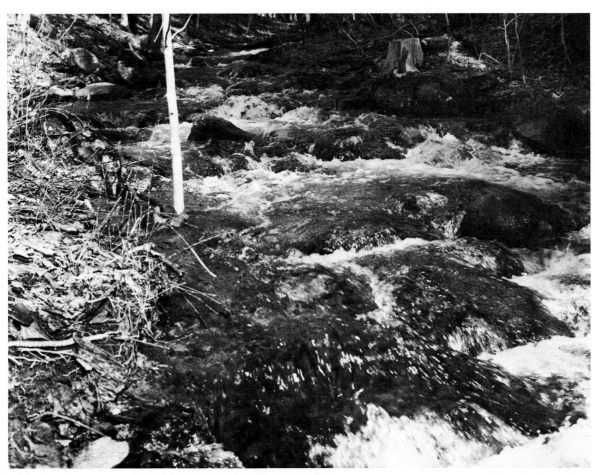

Photograph of the scene

Demonstration 12
A Brook
A watercolor painting

The snow was at last gone from the woods on the early spring morning that I chose to paint this watercolor in a place not far from my studio. The low sun cast long shadows among the bare trees and the ground was still winter brown. The water danced and sparkled as it tumbled over submerged rocks on its way to the nearby river. The week before it had been a cloudy yellow color as the result of silt carried by a heavy rain, but now it was clear and I could see the color of the rocks and gravel on the bottom. The gurgle of a woodland brook is a most pleasant sound and delightful company.

For this painting I chose to work on a less traditional surface — a smooth bristol paper. Such a ground lacks the absorbency of watercolor paper so that the color lies on the surface and the pigment settles into the puddles and dries in irregular tones. Yet some interesting effects are possible when the paint is applied in a fairly dry manner, similar to the effect obtained with acrylics used in the same way on a gesso panel.

In addition, I have also used white to achieve opaque color mixtures in the latter stages.

The colors used for this painting were burnt umber, Hooker's green deep, thalo blue, alizarin crimson, yellow ochre, cadmium orange and Chinese white.

Stage 1: After making a couple of small pencil studies for the composition I sketched the scene on the bristol paper with pencil.

I began painting in the upper right corner using a pale wash of yellow ochre, orange and a bit of green, working across the paper to establish an undertone for the distant trees. I left the white of the paper for the two trees since I thought I might utilize the paper for the lightest tones in this area.

As I neared the left side I used this same color for the two pieces of light colored ground — then using a fairly dry mixture of umber and green I put in the darker passage in the upper left corner. Here you can see how the brush strokes stay quite distinct when little water is used in the mixture.

Next, using umber and a fairly dry brush, the middle ground was painted with a #4 bamboo brush. I spread the hairs of the brush by pressing them firmly down onto my palette before I started painting and applied the paint in the more textured areas by pushing the splayed hairs against the paper.

Note: *This technique is rough on a brush so this is why I use the less expensive bamboo type. I reserve one brush just for this purpose.*

I next used a mixture of Hooker's green and umber for the darker tones in this area, to represent rocks. This same mixture was used for the foreground rocks, applied with a #9 round brush.

Stage 2: I began this stage by working on the water. First, the lighter areas were put in, using a mixture containing yellow ochre, green a a bit of white. Then the distant area was painted with Hooker's green. Where the water falls over the rocks I used green and umber. Note how these shapes indicate the downward curve of the water's flow. The foreground was put in with Hooker's green and here the strokes showed the swirling movement of the water.

Next, I went back into the distant area and put in the vertical strokes for the many tree trunks, starting with lighter tones and then the darker ones. I used the #0 bamboo brush.

Then I put in some diagonal strokes on the distant and middle-ground areas to represent the cast shadows of trees.

The dark rock on the opposite shore was lightened by scrubbing it with a damp sponge.

The area below the white shapes of the trees on the right was to be a shelf of rock extending out over the water. At this point I gave it a pale wash of ochre and then the darker band near the bottom edge was put in with umber, using the #4 bamboo brush. With this same color I added a darker tone to the shadow side of the center foreground rock.

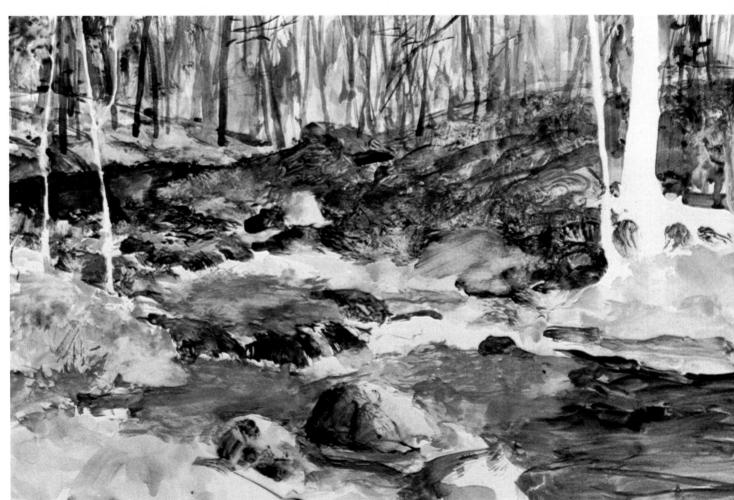

143

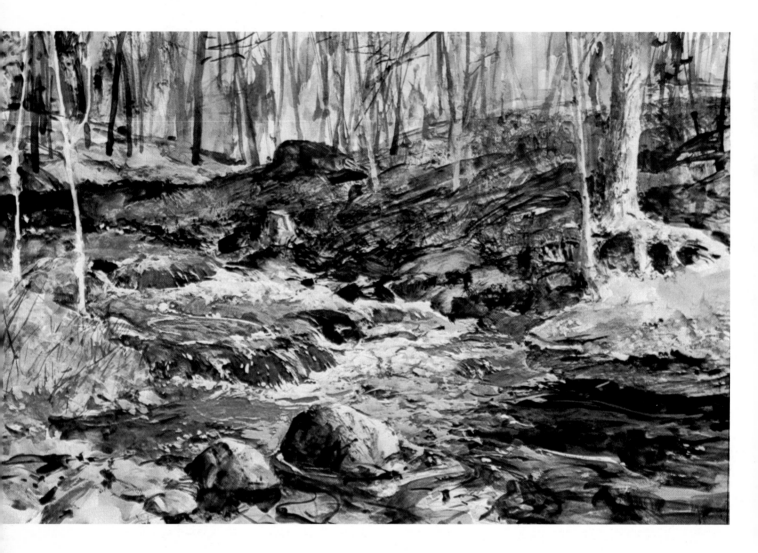

Stage 3: Now, working with my bamboo brushes and varied mixtures of transparent and opaque color I began refining the water (shown in the enlarged area on the opposite page). Generally I worked from dark to light, adding more white to the mixture as I progressed toward the lightest accents.

The larger light areas are at the base of falling water as it tumbles over the submerged rocks and is churned into foam. The most opaque color (white plus a bit of cadmium orange) was used for the sparkle of sunlight on the dark water as it falls over the rocks.

In the smaller reproduction above, you can see where I added dark passages among the foreground rocks to define the shapes and to further suggest the swirling motion of the water.

I next added more cast shadows to the ground on the distant shore, put in some dark accents on the rocks in that area, and worked on the two trees on the far right.

I then began to refine the overhanging rock below those trees.

Using my smaller bamboo brush I put in some vertical dark strokes in the land area on the left to indicate some growth.

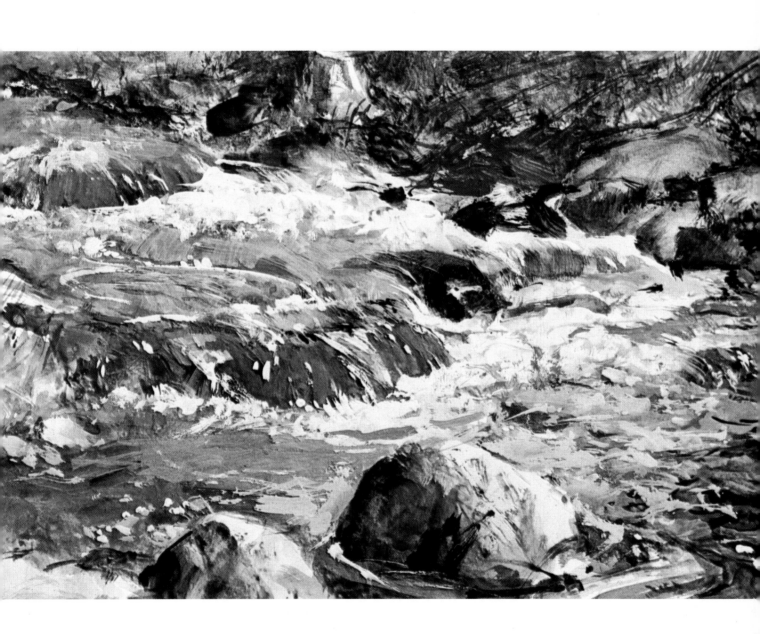

Stage 4: In the final stage I continued to make subtle adjustments in the water using opaque color or lifting out color with a damp brush. Then I worked on the distant hillside again, adding a larger dark tree trunk.

Further adjustments were made on the extreme right, particularly on the overhanging rock. Note the opaque branches in this area and the cast shadows on the rock.

With the painting complete, I decided to eliminate the more distant woods and a portion of the left side, so I cropped the painting as you see it here. I felt this arrangement concentrated the attention on the brook more forcefully.

When I have completed a painting I frame it with two L shaped mats. These can be adjusted to various sizes and shapes so that I can determine whether I've included more than is necessary for the best composition. If it turns out that the painting would look better cropped I then cut it down to the new proportions.

Spring Brook. Watercolor, 15 × 22 inches.

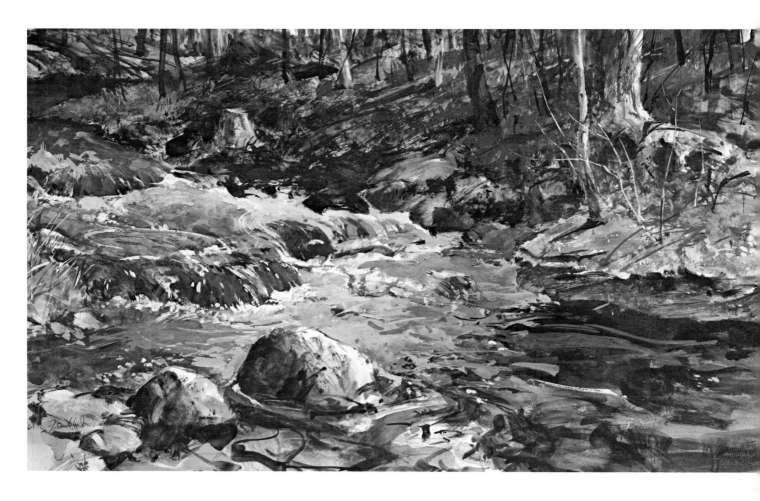

There's a song entitled "Rainy days and Mondays always get me down." Fortunately it doesn't apply to me. Rain, snow, and fog, offer a whole new look at the landscape, both in their visual appearance and in the moods they create. A gentle rain or snow falling straight to the ground quiets the land. Even the noisy vehicles that drive past seem hushed by the curtain that surrounds them. Fog creates a tapestry of delicate tones that appear to float above the land. The world disappears outside the small circle of my immediate place and I am completely alone.

In the fury of a snowstorm the air is filled with excitement, and breathlessly I watch the forms of nature dance and vanish as the wind whips about in every direction. Similarly the lashing rain and whistling winds set the landscape in motion as trees bend or the surf hammers against the coastline.

The task of setting up equipment may be more of a problem than the actual painting procedures. Usually I'm limited to working from the auto or some other shelter, though I will venture out into the elements if necessary to get what I want. Just recently I went out painting with a fellow artist, Don Getz, during a visit to his home in Peninsula, Ohio. We were working with watercolors up along a stream-bed and periodically the snow would fall so thickly as to actually cover the painting. I had to turn the paper over and shake away the snow. The paint refused to dry and I painted wet-in-wet through the entire session. Still, I was able to put down sufficient information to provide me with a guide for making another painting in the studio.

My painting of the snowstorm for this section of the book was done under more favorable conditions. I was able to work from my Volkswagen camper, a vehicle that serves as my home away from home when on painting trips.

I might point out that sometimes work done under adverse conditions forces me to work very directly and prevents my overworking the piece. Overwork can often destroy the artist's idea.

In one respect rain, snow and fog present a similar effect. As they go back in space the successive planes of the landscape are distinctly separated in terms of value, detail definition and form. This is more evident in fog and snow but is still a factor in rain.

Rain

For the impression of falling rain one can build up the painting with dominately vertical brush strokes, rather than strokes of varying directions that one normally uses. Or the images can be softly diffused and thin vertical strokes added to indicate the rain itself. Some artists prefer to imply the falling rain by merely softly diffusing the images and then showing the wetness of the roads and rooftops by making them very light in value.

As you can see, there is no single way to interpret the subject and the individual should allow his own impressions to dictate the approach.

Another consideration in painting rain is to use fairly muted colors to indicate the grayness of the atmosphere. Warm and cool grays would be most appropriate.

Falling Snow

To create an impression of falling snow the approach depends to some degree on the amount of snow in the air. In a heavy snowfall the background images are faint silhouettes. The colors are pale and cool. The nearby objects are more distinct, but would generally be cooler in color than in a normal land-scape. In addition, some light spatter work may be added to indicate the actual snowflakes.

For a light snowfall the images in the background can be more distinct, though not too detailed. The color would not be as cool in appearance as in the heavy snow. Foreground objects can be quite distinct, although detail should be minimized. In this instance, the use of light spatter work is a most effective way to indicate the falling snow.

Fog

In a painting of fog the main characteristics are a smooth surface, delicate tones and muted color for the simple silhouettes of middle distance and distant objects and, of course, the distinct separation of objects as they go back in space.

In watercolor, the soft effect of objects faintly silhouetted against a smooth curtain of fog can be most effectively done by painting directly into a wet paper. In addition some white pigment added to the color mixtures will provide a softness and uniformity of tone that may be desirable.

The colors in fog are predominantly pale grays of varying hues.

In all of these weather conditions the sky should be treated as a very simple tone of a delicate color.

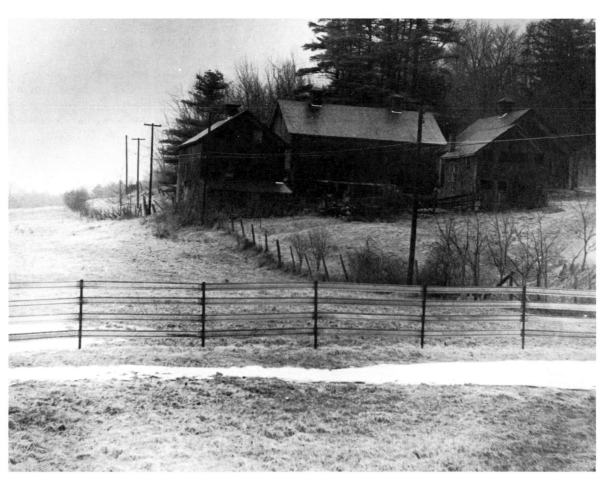

Photograph of the scene

Demonstration 13
Raining

A watercolor painting

It was early spring, and two days of constant rain had washed away all but the last traces of snow along the edges of the woods. The grasses lay flat and dull in the west pastures. I came upon this group of empty barns huddled together as though seeking protection from the rain. They looked dark and lonely in the landscape.

Unfortunately, I could not paint from my car which was parked some distance away. It was too wet to paint directly from nature. So I took a tiny notebook from my pocket and holding it close to my body, in the shelter of my broad brimmed hat, I made a pencil sketch, shown here actual size.

A sketch of this type may seem to offer little information for a painting, but remember, as I put down each line I'm looking carefully at the shapes, color and character of each object. There is more

information in my mind than on the paper, but I was able to put it there only because I made the sketch. . .which made me observe.

I also took a photograph, but not as reference in this instance since I didn't think it would tell me much. And, if I waited for it to be processed, I'd probably forget my immediate impressions. The photo was for use in the book. I drove home and started painting within the hour.

My paper, for the watercolor painting, is a half sheet of Arches 300 lb. rough. My palette consisted of the following colors: burnt umber, Van Dyke brown, burnt sienna, thalo blue, Hooker's green deep, yellow ochre and cadmium red light. The painting was done primarily with a ⅝ inch flat sable and a #9 round sable, though I also used my 1½ inch flat brush, a #0 bamboo brush and jackknife.

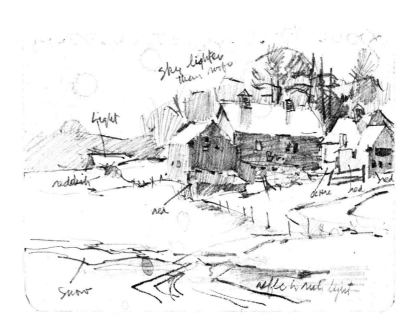

Sketch for Lonely Barns. Shown actual size.

Stage 1: Using the little study and my memory of the subject as a guide, I sketched the scene directly onto the watercolor paper.

Because of the large simple shapes in this subject and the fact that most of my lighter areas are in the distance, it seemed best to begin with the sky and proceed toward the foreground.

Deciding to begin working wet-in-wet to achieve a definite softness in the more distant area I filled my large flat brush with clear water and applied it liberally to the upper area of the paper, except for the roofs. These I wanted to remain fairly distinct.

While the paper was still very wet I went into the sky with a pale gray mixed from thalo blue and Van Dyck brown. This was put in with a few vertical brush strokes using the wide flat brush. Hardly evident when the area dries, it nevertheless gives a soft gray tone with a feeling of vertical movement.

Next, while the area was still wet, the trees were put in with a darker mixture of the blue and brown, plus a bit of green.

These background washes were allowed to partially dry and then a very pale gray of the color used in the sky was applied to the roofs of the barns using vertical strokes with a ⅝ inch flat brush. The colors ran together a bit to give a softness to the edges.

These roofs appeared darker than the sky in the actual landscape, but I made them lighter to strengthen the shapes in this area, the focal point of the painting.

Stage 2: I next put in the dark tones of the buildings using umber, cadmium red and a tiny bit of thalo blue. Again, I worked while the roof tones were slightly damp, so the colors would blend slightly to help achieve the feeling of seeing the forms through the falling rain.

At this point the area above the buildings was almost dry, so I put in some gray-green strokes to indicate a vague image of the pine trees that existed in the scene. I painted them less distinctly than I saw them in nature to be sure they didn't stand out too clearly.

Next, with a mixture of yellow ochre and umber, cooled with a bit of green for the most distant areas, I began to lay in a tone for the fields. Here I did not use the vertical strokes prevalent in the other areas, because this represents only an undertone for later washes. Also I wanted to give some feeling of the contour of the land.

Note the ground washes stop short of the foreground, for at this point I decided to apply a cool tone over the ruts that lead into the field. In all areas of the painting I have worked from light to dark in the usual manner of working with watercolor. The ruts will be lighter than the surrounding ground for they are shiny wet.

When I decided to stop in the middle of applying the color to the field I was careful not to leave the bottom edge as a straight line across the paper. If the color dried before I got back to it, it would leave a line that would show through later washes. So I varied the edge in character with the rough field.

Stage 3: I next completed laying in the tone for the ground, leaving the light ruts showing.

At this point I decided to darken the buildings and define some of the edges a bit more. While I do want to keep the images somewhat indistinct through the rain, I still wish to emphasize these buildings enough to make them an important focal point. So I went over them with darker mixtures of browns and reds.

You will see that I've shown a tonal difference between the front and side planes of the buildings. Although we have no sunlight and shadow in this scene, there is more light reflected into the side planes of the barns because of the open landscape in this area. This value difference gives a three dimensional look to the buildings.

Now the washes on the fields had dried sufficiently and I went back over them with slightly darker colors using the flat brush. Applying one wash over another in this manner gives a feeling of roughness to the fields that would not be as evident if we painted them with a single layer of color. My brush strokes curve a bit or vary in direction in order to give some form to the contour of the land.

At this stage of the painting I feel the values in the field areas are not yet dark enough to give the impression that I'm after. . .that of an overcast rainy day.

Stage 4: Once more I went over the fields, adding a bit of thalo blue in some areas to give a cooler look to the scene.

Now it was evident that the buildings needed to be darkened, for I want their shapes to stand out darker than the fields. I went back over them again, making some edges even more distinct than before. If there had been other large forms in the foreground, such as buildings or trees, I would keep these distant barns lighter to give more depth to the scene. But here they represent the main interest in the painting and so I emphasize their value contrasts.

To preserve a feeling of distance and the curtain of falling rain that exists I have intentionally omitted the many windows that I could see in the actual scene. I did include one, very faintly, in the center section that the viewer might observe on a close examination.

I now put in the vertical streaks on the light roofs that represent reflections of the cupolas. These reflections help convey the wetness of the roofs as distinguished from a covering of snow.

Next, with my small bamboo brush, I put in the fence posts leading to the barn and in the barn area. While these details are not any more obvious in the scene than the windows, they do help describe the character of this place — so I put them in.

I dragged some color lightly over the ruts in the foreground. This dry-brush texture helps give the impression that we can see detail more clearly in the nearby areas. To further this effect I also put in some very fine lines to indicate the presence of grass stalks. A couple of fence posts complete the scene.

Finally, to show the presence of falling rain, I used the point of my knife to scratch thin vertical lines through the dry paint.

Lonely Barns. Watercolor, 15 × 22 inches.

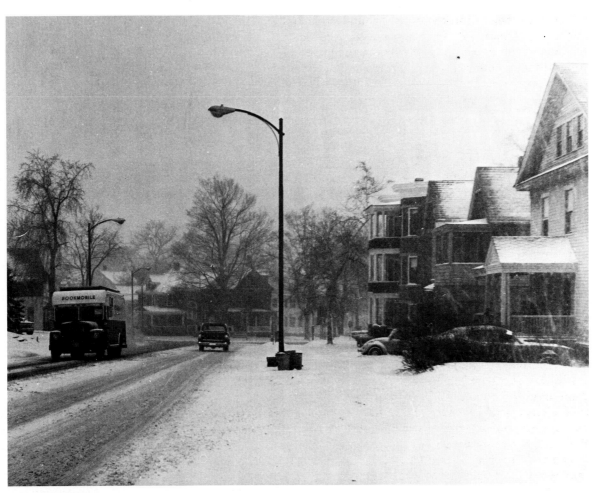

Photograph of the scene

Demonstration 14
Falling Snow

An oil painting

The snow began thick and fast around noon and by late afternoon, when the lights were beginning to show in the houses, it had covered the ground some three or four inches. When most souls were trying to get home to the warmth of their hearths, Florence and I were out searching for a subject to paint for this book.

I chose this scene on the outskirts of the city because it offered the opportunity to show the effect of falling snow on near and distant forms. However, there were certain things I didn't like about it so some revisions were made.

First, I replaced the house furthest down the street on the right with the one shown at the extreme right in the photograph. I preferred this shape to the others which I considered irrelevant to my idea. I also moved the trash cans down the street. Then I narrowed the street and gave it a curve to avoid the strong overpowering thrust of the actual scene.

This painting could have been completed on the scene since we had the comfort of our V.W. camper to work from. However, since the light was not compatible for photographing the various stages of the demonstration, I chose to lay in the first stage and then complete the work in the studio. A number of photographs were taken of the different elements of the scene for reference.

The painting was done on an 11″ × 16″ sheet of canvas textured paper, sold in art stores for sketching purposes.

My colors were as follows: burnt umber, cerulean blue, alizarin crimson, yellow ochre and titanium white.

I used flat sable brushes in sizes #1, #3, #4 and #5. Also a round bristle brush, size #3.

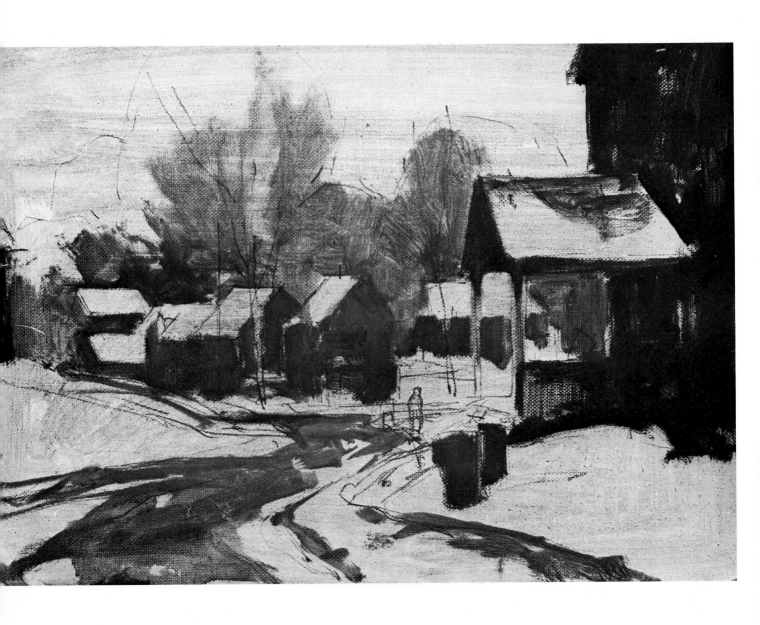

160

Stage 1: I first toned the surface with a gray color mixed from cerulean blue and umber. Then I sketched the major shapes with a charcoal pencil.

The building on the right, being the darkest form, was roughly painted with varied mixtures of umber, cerulean, alizarin and umber using the #4 and #5 flat bristle. The reason for putting in this building first was to give me a guide for establishing the distant values.

Next, using a mixture of umber, cerulean blue and white, the buildings at the end of the road were put in. I intentionally made these a bit darker than I intended them to be, so I could build lighter tones into them later.

With a slightly lighter mixture of the same color the distant trees were scrubbed in with thin paint. I left the light roofs showing, so I could envision the tonal pattern of my composition.

I also laid in a base color for the road, trash cans and the house on the far left. The house was a mixture of umber and ochre.

Stage 2: Using the photographs and my memory of the scene as a guide, I began developing the structure of the house on the right, using thick paint. The thin forms of the porch posts are ignored at this point, since it will be easier to define them over the background. Similarly, I put in the porch rails as a simple tone at this stage. The cans were painted next.

I began developing the distant houses and trees to create the impression that we are seeing them through the curtain of snow. To achieve this effect I used quite thick paint mixtures and applied the paint with my smaller flat sable brushes using very short brush strokes. The color was slightly lighter than the undertone, and some of this under color was allowed to show between the small strokes. It is this intermixture of slightly varying tones that gives a vagueness to the forms. Edges are indistinct and no form is evident in the buildings.

The trees were done with larger strokes than the buildings but with the same approach. All of these distant areas are painted with a blue-gray mixture of cerulean blue, umber and ochre.

The house on the far left was also adjusted at this point.

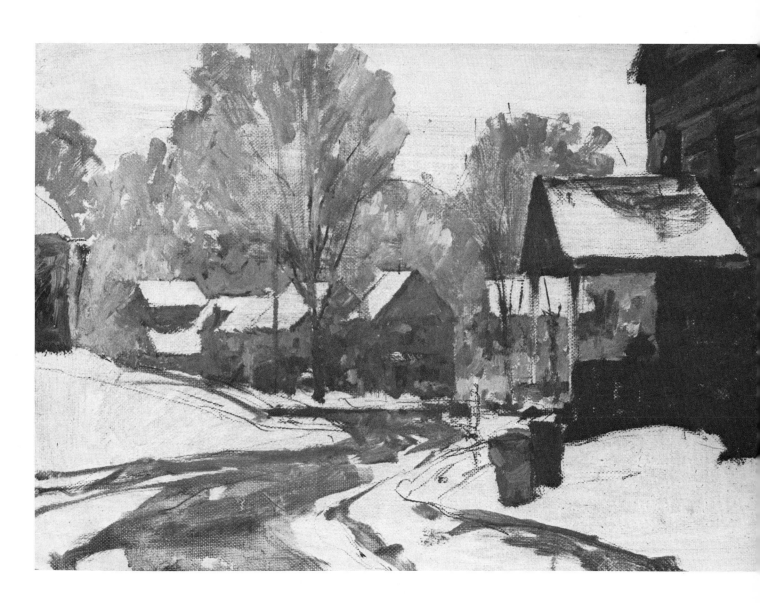

Stage 3: The sky and the upper parts of the trees were painted next with the same monochromatic color. The sky was first given a fairly thick layer of paint. Over this, using a slightly lighter mixture, a patchwork of strokes was used to again produce a vagueness of tone. The strokes were applied in all directions.

With all of the major darks established, I next laid in the snow with thick pigment. To achieve an effect of the late afternoon light the snow was slightly grayed with cerulean and umber.

I also worked on the road at this point.

With the overall painting fairly well indicated I could now determine the value adjustments that were needed. So once more I went back into the distant houses and trees to lighten them a bit more, making very subtle changes.

It was evident at this stage that the building on the right was too dark. There is no feeling that we are looking through the falling snow. The shadow under the porch roof is particularly dark for this impression. I also felt the composition would be better if there were some dark accents on the left.

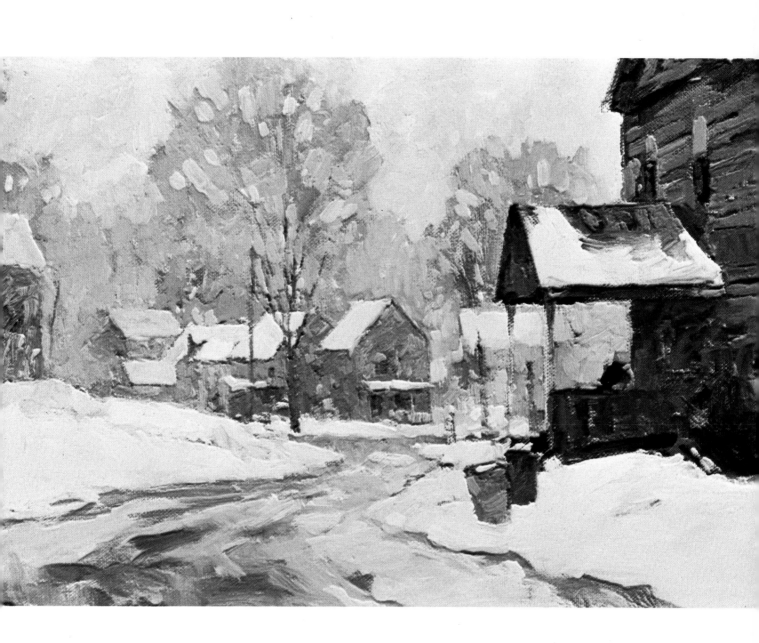

Stage 4: Now I adjusted the values of the building on the right. There should be no real dark in this scene, for everything is affected by the falling snow.

While working on the building, I refine those areas previously ignored, such as the porch rails and posts. I've also added the bush next to the house and worked on the trash cans.

I then put in the figures and darkened the electric pole. These provided the darks I needed to balance with the right side of the painting. You'll see that I took out the small figure directly over the cans. This area was too crowded — too much going on in such a tight space. Moving the figure to the left was better.

Further development of the road came next, particularly in the foreground where I wanted the road and snow banks to blend together. In this instance I want the viewer's eye to move into the distance and not be attracted to this foreground too much.

Subtle adjustments have been made in various areas and the painting is just about completed, so I used my small pointed sable brush to put in some individual snow flakes over the dark form of the building on the right. This is where they would be most evident to the eye.

Finally, in the center of the painting, I put in some light ochre color to indicate the warm glow of a window. I repeated this in one of the upper windows of the foreground building.

Winter Storm. Oil, 16 × 20 inches.

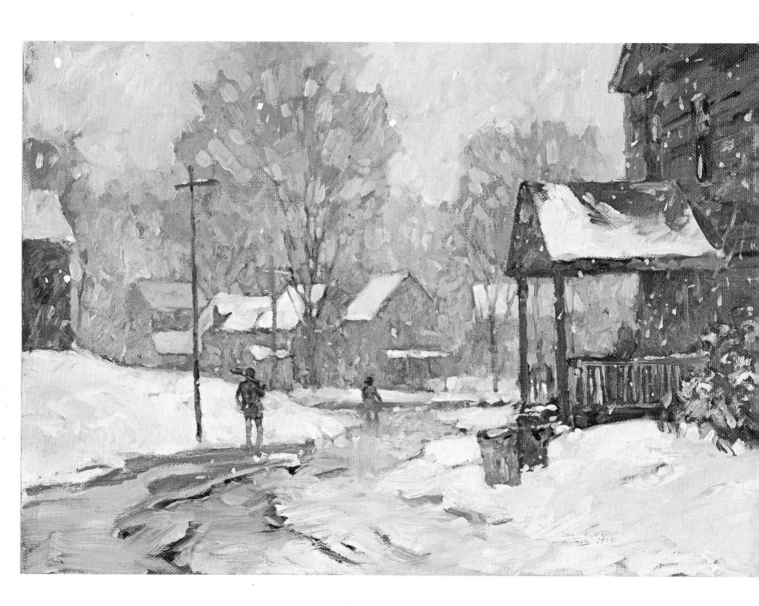

Pencil study of harbor, FOG LIFTING

Demonstration 15
Fog

A watercolor painting

Fog may engulf the land and sea so completely that one can barely distinguish those objects some ten or twenty feet away. Sometimes it may stretch out in a long train along the face of a mountain or it may hover over unseen streams. There is the soft veil of morning fog that settles low across the meadows and tidal flats, dissipating as the sun filters through to warm the summer air.

Along the Connecticut shore I observed some clam diggers out on the flats, and the fog hung so close to the ground that the building on higher ground seemed to float in space.

I had intended that this painting would only be a study for a larger piece (it's only 7 × 10 inches), but as I started painting I thought it would be interesting to use this more spontaneous effort as an example for this book. The procedure is exactly the same as I would have used for the larger piece.

Some artists like to soak the entire paper and work directly into the wet surface to produce the soft blending of tones for such a subject. I prefer to work on a dry surface, wetting only those areas where I feel it is necessary. I feel this gives me greater control of wet and dry edges.

This painting was done on a 7 × 10 inch block of 140 lb. rough watercolor paper.

All of the work was done with a #7 round sable.

My colors were thalo blue, burnt umber, alizarin crimson and cerulean blue.

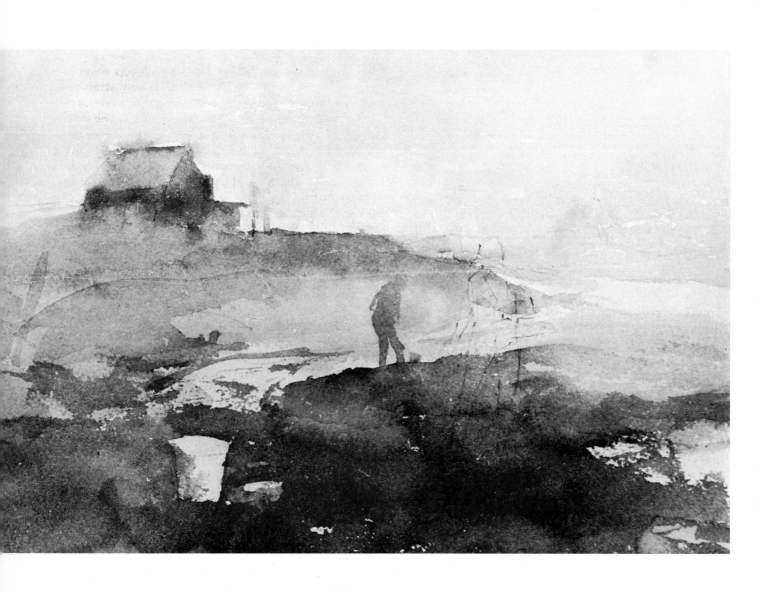

Stage 1: The scene was sketched with pencil, with no preliminary planning. At that point I blocked in the foreground figure, but the others were added spontaneously as I saw a pose that seemed appropriate for the scene.

It is generally better to work with the wet-in-wet areas first, and, as I've previously indicated, one frequently works from background to foreground. With this in mind I first loaded my brush with a very pale warm gray of thalo blue and umber. This was brushed over the entire sky and distant piece of land on the far right. I went around the building on the left, for I intended to have it stand out fairly strongly to give the impression that it looms above the heavier layer of fog.

While the sky was still very wet, some thalo blue was brushed into it on the far right to establish the most distant land and building. The image all but disappeared as the color blended into the sky.

Next, still working with a very wet sky, I brushed in a darker mixture of blue and umber, starting with the building on the left and working down as far as the middle of the figures. You will see that in some places my brush touched the wet sky causing the color to spread into that area. In other places the color was applied to dry paper and the edges are distinct. This combination of lost and found edges produced the vagueness of the shape that I wanted.

While this blue wash was still very wet, I rinsed my brush clean, wiped it fairly dry and dragged it through the lower part of the wash to lift some of the color (this is the area through the center of the painting).

While the blue wash was still damp, I prepared a darker mixture of blue and umber and put in the darker tones on the building. The distant areas were now complete.

Using the same dark mixture as on the house, I began in the left middle area to establish the ground. The figure in the center was put in with the same color.

The rest of the foreground was put in using a brown, mixed from umber and a bit of blue. The white of the paper was left for the areas of water and the lighter parts of the pail in the foreground.

Stage 2: While the figure in the center of the painting was still damp I put in a darker blue-gray color for the seat of his trousers. The color blended into the surrounding areas slightly to give a soft effect.

With a slightly warmer gray I touched the tip of the brush to his arm. The color spread into the damp area. I find this approach of indicating the entire figure with a single color and then dropping in other colors while the area is still wet or damp a very useful technique for any small figures.

Next, the hat was put in with the same gray.

Then, with fairly dark umber, I went over the foreground again. In the areas of the light water I dragged a fairly dry brush quickly over the surface to suggest the sparkle of light.

When this wash had dried I again went over the ground with still darker shapes.

Again the area was allowed to dry and I repeated the operation, this time using a variety of small strokes to indicate the roughness of the mud.

To complete this stage a medium-dark wash of umber was used to put in the figure of the nearer man.

Usually I leave my pencil lines, but in this instance they were too dark so I lightly erased them with a kneaded eraser.

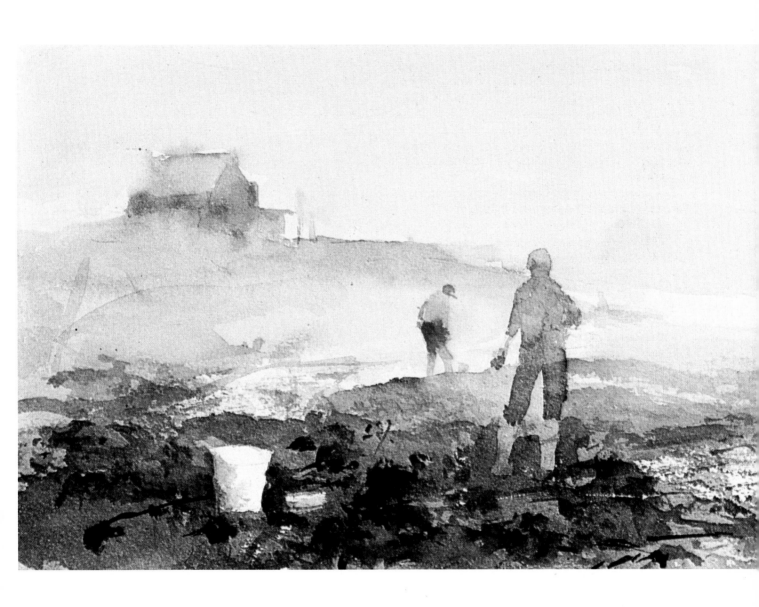

Stage 3: Using the same approach as for the other figure, a dark umber was dropped into the trousers and shirt. This time I blotted the trousers once with a wad of Kleenex. Then a fairly thick bit of cerulean blue was brushed into the shirt area. This lightened the area a bit and gave a color to the shirt.

I completed the figure by putting in the dark hat, the handle of the fork and just an indication of suspenders.

The third figure was then added in the same manner as the others. Against the lightness of the fog these figures appeared almost as silhouettes. Each is less distinct as they recede into the mist.

I added a few more dark shapes to the foreground with a mixture of alizarin and umber and then completed the pail. Finally, the tall poles were put in with a pale gray.

Working the Flats. Watercolor, 7 × 10 inches.

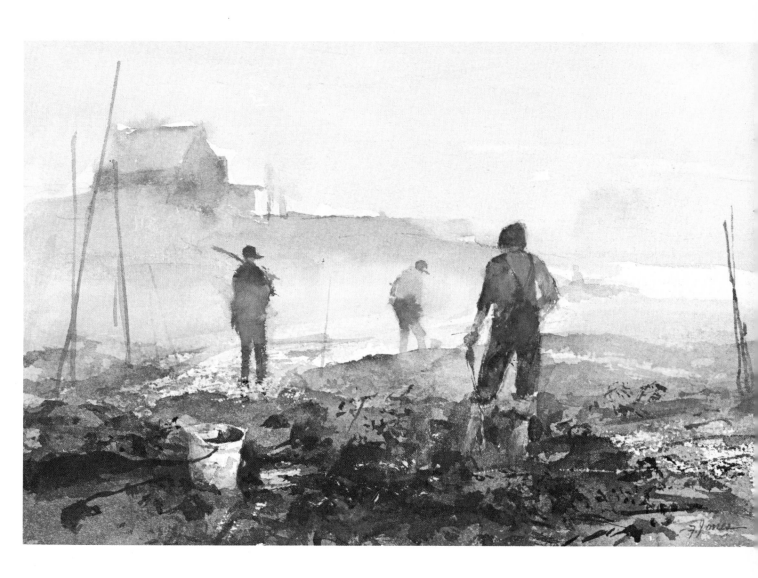

Study of harbor rock and a fellow artist, Stonington, Maine, 1977.
Pencil on plate finish bristol.